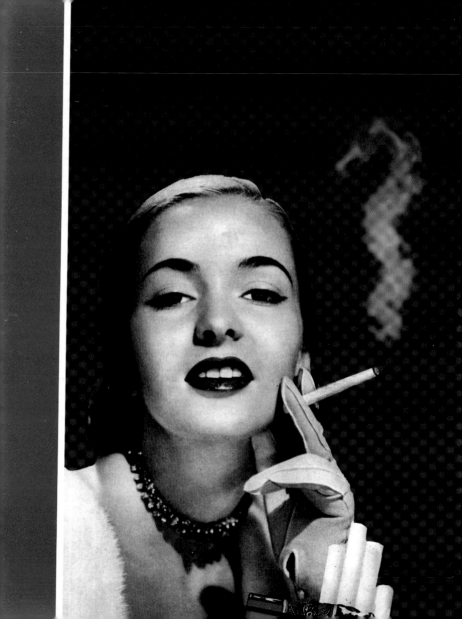

What's your Poison?

ADDICTIVE ADVERTISING OF THE '40s – '60s

by Kirven Blount

COLLECTORS PRESS

PORTLAND, OREGON

Book Design: Lisa M. Douglass, Collectors Press, Inc.
Project Manager: Jennifer Weaver-Neist
Editor: W. Gail Manchur
Proofreader: Julie Steigerwaldt

Library of Congress Cataloging-in-Publication Data

Blount, Kirven, 1968-
 What's your poison? : addictive advertising of the '40s - '60s / by Kirven
Blount.-- 1st American ed.
 p. cm.
 ISBN 1-933112-02-6 (pbk. : alk. paper)
 1. Advertising--Tobacco--United States--History--20th century. 2.
Advertising--Cigarettes--United States--History--20th century. 3.
Advertising--Alcoholic beverages--United States--History--20th century. I.
Title.

HF6161.T6B57 2005
659.19'6412'097309045--dc22

 2005000896

Collectors Press books are available at special discounts for bulk purchases, premiums, and promotions. Special editions, including personalized inserts or covers, and corporate logos, can be printed in quantity for special purposes. For further information contact: Special Sales, Collectors Press, Inc., P.O. Box 230986, Portland, OR 97281.
Toll free: 1-800-423-1848.

For a free catalog write: Collectors Press, Inc., P. O. Box 230986,
Portland, OR 97281. Toll free: 1-800-423-1848 or visit our website at: collectorspress.com.

CONTENTS

INTRODUCTION

Advertisers love a challenge. Tell them you want to market a new line of cars that aren't all that sexy-looking and tend to ignite upon collision, and they'll jump at the chance to pitch you their concept. Selling ice to Eskimos is nothing — even the greenest interns can do that. So present them with the chance to market toxic substances and you've got a captive audience. Tell them these same substances are addictively intoxicating and they're on the team for life. In the 1940s, 1950s, and 1960s enticing smokers and drinkers was like shooting fish in a barrel. The target audience loved its vices and was blissfully unaware of the significant downsides. Leafing through their favorite magazines, Mr. and Mrs. Middle America saw people of class and distinction cavorting or relaxing, depending on their mood, grinning in their perfectly pressed slacks as a smooth-tastin' cigarette and/or libation cleared a path to contentment. If ignorance is bliss, it was a Golden Age indeed.

Vices have always been with us, of course, and have had no need of some fast-talking pitchman in a sharp suit to establish them as indispensable. A brief history:

Early in human history to be in the thrall of a vice, to be vice-ridden, even to dally in vice was not defined as a specific practice. It was more of an umbrella concept, and it was easy to know when you were being bad. The Capital Vices (or, more dramatically, the Seven Deadly Sins) were clear to all: Pride, Covetousness, Lust, Anger, Gluttony, Envy, and Sloth. Excess in any of these prescribed areas was vicious, and your choice was to stop and repent or be burned, or drowned, or if you were lucky, just stoned (you know what I mean). With increased sophistication came an ever-more complicated definition of vice.

Drinking and smoking are the first things that come to mind when anyone thinks about vice, yet they are products of very innocent, natural processes. Nicotine, the addictive ingredient in cigarettes, is actually a poison produced by the tobacco

plant to ward off herbivores. Ingest it in sufficient quantity, and your days as a plant eater are over. This hint of danger, a necessary element in any vice, has always contributed to the allure of smoking. As Kurt Vonnegut put it: "The public health authorities never mention the main reason many Americans have for smoking heavily, which is that smoking is a fairly sure, fairly honorable form of suicide."

Ethanol is nicotine's sister poison, and it's what makes that shot of hooch burn on the way down. It's created naturally when airborne yeast encounters and "eats" sugar. The result, ethanol, is actually a waste product. Looked at this way, one's Zinfandel seems a bit less refreshing. But yet again there is a poisonous substance involved, and the living-on-the-edge factor ups the attraction. Nietzsche, who knew a thing or two about human behavior, said "the one conclusive argument that has at all times discouraged people from drinking a poison is not that it kills but rather that it tastes bad." And even that doesn't work.

An oft-told story describes a woman in the court of King Jamshid, a Persian ruler in 3000 B.C. Apparently the woman had had it up to here with 3000 B.C. life and decided to end it all. The surplus grapes from that year's bountiful harvest had turned, been labeled POISON, and tucked away somewhere. The woman wasted no time in drinking her fill, but instead of expiring she became deliriously happy, told everyone in the court how much she loved them — really loved them — then passed out. The king instantly began marketing this accidental elixir as "Delightful Poison" and then later became an iron-fisted hip-hop mogul. We think. What we know is that the alcoholic beverage was born.

When Columbus noticed the natives of the West Indies "drinking smoke" (and that his men had a little trouble stopping when they joined in) he decided to bring some tobacco seeds back with him to Europe. They were a big hit. John Rolfe saved the Jamestown colony by creating and harvesting a milder hybrid blend and exporting it to Britain, laying the groundwork for the American tobacco industry. John Rolfe's bride-to-be, Pocahontas, who legendarily spared the Jamestowners's scalps, may also have slipped Rolfe some tobacco curing and drying techniques, learned from the tobacco-harvesting men of her Powhatan tribe. By 1619, about ten tons of this amazing new diversion had been exported to Europe. By 1627, 250 tons had been shipped over; by 1639 it was 750.

Booze had been a close friend to Britains, and the relationship more than survived the trip to America. Water was not held in high regard, partly because it had a tendency to generate microorganisms, partly because of the odd belief that cold water on a hot day could be lethal, and partly because it made itself so readily available (maybe water should have played hard-to-get). Faced with the prospect of slaking their thirst with that clean, clear, omnipresent unmentionable, the colonists went to great lengths to produce beer, cider, and wine and import vast quantities of rum. The colonists introduced the Native Americans to alcohol, and then quickly set up a barter system with those who were willing to spare a little tobacco. The enthusiastic response on both sides had a seismic effect on both cultures.

Nearly every important meeting held by our forefathers as they threw off the yoke of British imperialism took place at a drinking establishment. The City Tavern in Philadelphia was known as "the great gathering place for members of Congress." The headquarters of the Minutemen was Buckman's Tavern on Lexington Green in Boston. Paul Revere stopped in and had two drafts of rum at the home of Isaac Hall before his big ride. In celebrating their achievement, the fifty-five drafters of the U.S. Constitution ran up a tab of fifty-four bottles of Madeira, sixty bottles of claret, eight bottles of whiskey, twenty-two bottles of port, eight bottles of hard cider, twelve beers, and seven bowls of punch that were so big it was said that ducks could swim in them.

The onset of liquor taxation in the 1790s gives us the first record of alcohol consumption. At that point the average American was consuming thirty-four gallons of beer and cider, a little over five gallons of spirits, and just under a gallon of wine a year. George Washington's reaction to a delayed shipment of booze for his men elicited this comment in a letter to the president of the Continental

Congress: "The benefits arising from the moderate use of strong Liquor have been experienced in all Armies and are not to be disputed."

Throughout the nineteenth century, booze and smokes were enjoyed freely and liberally. The hard work of creating a nation from scratch demanded some blowing off of steam. As we made the transition from an agrarian to an industrial society during the Progressive Era (roughly the 1870s through the 1920s), vices began to be viewed in a new light. For one thing, there was a new political restlessness and an excited impulse to reform society. Efficiency was paramount, and vices started to look like impediments to progress. People were moving to the cities, and more and more men were smoking and drinking in taverns. Temperance types saw a looming threat to the nuclear family, which accounts for the formation of the Women's Christian Temperance Union, and the temperance movement in general. One of these temperance fighters found a way to make booze work for her, and in the process revealed something about how liquor was seen differently when repackaged. Lydia Estes Pinkham started one of the first widely successful female-run businesses by marketing her "Vegetable Compound" as a "woman's ills" panacea. The wonder potion's 20 percent alcohol content was said to act only as a "solvent and preservative." If you felt happier after taking a dose, well, that was due to the very potent vegetables.

Then around the turn of the twentieth century, the Soldiers of Temperance (e.g. Billy Sunday and Lucy Page Gaston) stepped in and called a halt to anything that seemed like fun. The revelers were a little too hung over to protest, and suddenly we found ourselves in the midst of Prohibition. Of course, there are those who say that political and economic factors (the rise of alcohol-focused immigrants and tax evasion in the liquor industry) were the true causes, but it couldn't be more obvious that it was more a matter of the squares resenting the swells and doing something about it early in the morning.

Eventually it became clear that, as usual, the squares were overreacting. The taxes that booze brought to the economic table were substantial, and the revenue loss was felt in a big way. (The same was true of tobacco, which generated an increasing amount of tax dollars, from $80 million in 1915 to $1.3 billion in 1948.) At a time when jobs were highly coveted, the liquor industry's potential

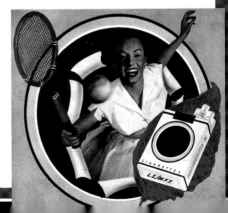

as an employer was hard to ignore. Then there was the energetic circumvention of the Eighteenth Amendment, which got legislators worried about disrespect for laws in general. The people were beginning to feel empowered by how easy it was to be a scofflaw, and a tipsy scofflaw at that. FDR (who was rarely seen without a smoldering butt in his jaunty cigarette holder) was elected in 1933 as a repeal candidate, and repeal Prohibition we did, that same year, with the Twenty-first Amendment to the Constitution.

Although given a new lease on life, drinking, smoking, and impaired jollity in general retained a residue of stigma. Before the hullabaloo, the tavern had been an essential gathering place, providing a spot for members of a community to interact at their leisure, coming and going as it struck their fancy. Walt Whitman celebrated the noisy oasis in *A Glimpse* in 1856:

A glimpse through an interstice caught,
Of a crowd of workmen and drivers in a bar-room around the stove
late of a winter night, and I unremark'd seated in a corner,
Of a youth who loves me and whom I love, silently approaching and
seating himself near, that he may hold me by the hand,
A long while amid the noises of coming and going, of drinking and
oath and smutty jest,
There we two, content, happy in being together, speaking little,
perhaps not a word.

The temperance movement all but wiped out these idyllic watering holes, and as a result society became more polarized. What once were genteel public houses now became saloons (i.e. places to get ripped) and nowhere more so than in the Bowery in New York City. Delightful spots like the Flea Bag, the Hell Hole, the Dump, and the Morgue appeared, fully devoted to the pursuit of obliteration. One saloon served up a cute little concoction that mixed whiskey, hot rum, camphor, benzene, and cocaine sweepings — all for six cents.

When World War II erupted, those that depended on them were happier than ever to have access to their vices. After the Japanese bombed Pearl Harbor, Americans suddenly felt vulnerable. The image of the United States as an impenetrable model for the world was shattered. Cigarettes and booze were pacifiers, and Americans turned to them with regularity. Tobacco and alcohol companies began emphasizing the soothing properties of their brands in response.

Magazine readers were told that "Chesterfield is just naturally called the smoker's cigarette. They Satisfy." and that "Camels never make me edgy or nervous." Model pipe tobacco's ad went like this: "Lay on a friendly flame. Then settle down to the calm contentment of those creamy clouds of grand-tastin' smoke." You can almost nod off just reading it.

It was an exhausting time, so products began to tout energy-providing properties. Kellogg's created a breakfast cereal called Pep. Knox Gelatine was trumpeted as "a food that fights fatigue." While this may come as a surprise to those who have nodded off at the height of a keg party and woken up covered in shaving cream, beer was no exception. "Enjoy Guinness when you're tired" went one ad, which explained that the beer that eats like a meal "contains active yeast." Guaranteed to keep you going all day!

There were those who suggested that, as a part of the war effort, perhaps the consumption of alcohol amongst American soldiers could be curtailed (as it was at home). After all, the elements that went into the brewing of beer could be used for more essential things, like eating. But General George C. Marshall, Chief of Staff of the U.S. Army, wouldn't stand for it, saying such a prohibition would be "harmful to the men in the service."

When the dust settled, it became clear that women were partaking in vices more and more. Whereas societal mores had limited their ability to cut loose (too much of a threat to male-dominated society's status quo), now they had done things like influence Prohibition and perform well at so-called men's work during the war. Although women were rushed back to the kitchen as soon as their men returned from the fighting, they liked the empowerment, and they never forgot it. And while the 1950s was all about the loyal housewife, the equal rights movement emerged and soon flourished. As they carved out a more influential spot in society, women began to drink and smoke like the boys. A 1939 Gallup survey showed that 70 percent of men but only 45 percent of women drank alcoholic beverages. By 1986 it was 70 percent men, 62 percent women. The smoking prevalence among women in 1924 was less than 6 percent; by 1965 it was 34 percent. The stigma attached to women and vice has never gone away,

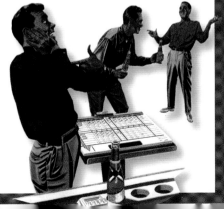

but women are increasingly shrugging off the strictures and asking why on earth shouldn't they be allowed to beer bong right alongside the men.

After we made our way through the Korean War, we pretty much had enough of being unsettled. The prevailing sentiment during the 1950s and early 1960s held that this was a utopia, no matter what anyone said. Women stayed home, men went to work. And getting loaded was part of the job; any man who declined the after-work drink (or the drink during lunch, for that matter) was not to be trusted. You didn't get the key to the executive washroom unless you could throw a few back with the big boys. In her memoir, *Note Found in a Bottle*, Susan Cheever described how the culture of drink in the 1950s affected daily life:

> In the evenings, I would greet my homecoming hubby with the ice bucket and the martini shaker. On Sunday mornings we would have Bloody Marys. In the summer we would stay cool with gin and tonics. In the winter we would drink Manhattans. In the good times we would break out the champagne, in bad times we would dull the pain with stingers.

One thing you didn't do was give voice to any kind of ugly truth, for fear it might be acknowledged. In 1953 President-elect Dwight Eisenhower refused to reappoint Eleanor Roosevelt to the American delegation to the United Nations because he thought she gossiped about his wife's alcoholism. It just didn't do to bring up the unpleasant.

Of course there were plenty of people who chafed under the rigidity of this setup, and their numbers grew steadily. The Beats found their counterculture voice through their dissatisfaction with cookie-cutter culture. William Burroughs, Allen Ginsburg, and Jack Kerouac resisted conformity, and drinking and drugging themselves silly was one of their central tactics. (Kerouac was an inveterate drinker, and died of cirrhosis of the liver at age forty-seven.) They were admired and followed, and opened the door for the hippies to come dancing in. Vices were a huge part of this whole evolution, though they were no longer a catalyst for snappy repartee and junior league socialization, at least not according to the hippies. Intoxication was more and more about mind expansion and individualism as freaks became more and more acceptable. The flameouts of icons like Jimi Hendrix and Janis Joplin are pointed to as indicators that mind expansion got a bit out of hand,

but they were just the high-profile cases. Untold millions just wanted to break the close-knit suburban mould and wear a caftan with nothing underneath. A few belts or a hit off the hooka made it feel so much more right somehow, and the end result was not asphyxiation in most cases.

Some might see these modern times of ours as hollowed out and excessively puritanical, and the truth is that in some places it's probably true (on the surface).

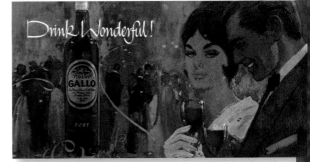

Nationally, the Women's Christian Temperance Union is still going strong, boasting a membership of twenty-five thousand. Gene Amondsen and Earl F. Dodge both ran for president in 2004 under the banner of, yes, the Prohibition Party.

But rest assured, vice is alive and well and always looking for a way to show you a good time. In the tech boom 1990s, when just about everybody was a millionaire and we experienced a high times resurgence, the cool nightlife motif was a throwback, martini-and-cigarette-girl kind of thing. Vegas is more popular than ever, and it's even broadened its appeal to include families. "Celebrity Poker Showdown" and "Celebrity Blackjack" are two fairly popular cable shows (we love to see our icons lose money), celebrating gambling while maintaining the necessary reality-show feel. Frank Kelly Rich publishes *Modern Drunkard* magazine, which he says exists for those locked in a struggle with the "neoprohibitionists from the left and right."

While our vices have developed and changed, the pitchmen have stayed abreast of every development, pumping out spots that negotiate the prevailing winds of opinion. As we evolve and our reasons for needing to get altered change apace, the variety and sophistication of ads currying our favor evolve as well. The 1940s, 1950s, and 1960s comprised a Golden Age of vice advertising, as companies jumped through the hoops, filling magazines and newspapers with beautiful, deliriously happy people drinking and smoking and living it up. In this world, the elixirs were always golden and the smokes always lighter-than-air. Joining in just meant a quick trip to the corner store.

CHAPTER ONE

Take It from Me
Testimonials of Vice

Look! when a man drinks, he is rich, everything he touches succeeds, he gains lawsuits, is happy and helps his friends. Come, bring hither quick a flagon of wine, that I may soak my brain and get an ingenious idea.
—Aristophanes, 424 B.C.

To practice one's vice or not to practice one's vice: it has never been a simple question. It helps to hear a voice you trust urging you on. You may be surprised to know that the Good Book actually provides a little vice promotion. Proverbs 31:6 says: "Give strong drink unto him that is ready to perish, and wine unto those that be of heavy hearts. Let him drink, and forget his poverty, and remember his misery no more." Kind of hard to see this as anything other than a blank check for the Bible-toting drinker.

Socrates went on record as saying that wine "does of a truth 'moisten the soul' and lull our griefs to sleep." Everyone loves a little soul-moistening now and again. In the late sixteenth century, Thomas Nashe was sold on booze as an essential study aid: "Give a scholler wine, going to his booke, or being about to invest, it sets a new point on his wit, it glazeth it, it scowres it, it gives him acumen." Of course Nashe was later jailed, as much for his outspokenness as for his rough and rowdy ways. But he convinced more than a few people to go ahead and get ripped.

In the eighteenth century, Alexander Pope saw drink as a buffer when the world was too much with him:

> *A little learning is a dang'rous thing;*
> *Drink deep, or taste not the Pierian spring:*
> *There shallow draughts intoxicate the brain,*
> *And drinking largely sobers us again.*

As sober-sided a man as World War II-era Major Grayson M.P. Murphy was willing to lay it down for that little white slaver, the cigarette: "In an hour of stress, a smoke will uplift a man to prodigies of valor; the lack of it will sap his spirit."

With this rich tradition of promotion of vices to draw upon, advertisers took courage. Clearly there was a groundswell of support for the tools of vice; they had only to tap in.

Banking on the principle that a chorus works where a lone voice falters, advertisers went grassroots. In the 1940s and 1950s, Camel touted its thirty-day mildness test by running ads with groups of people-on-the-street testifying that Camel was the cat's meow. Calvert Blended Whiskey dotted one ad with the faces of fellows like Johnny Duke and E. de Solminihac, everymen who had made the switch to Calvert from less amazing whiskies (Johnny bought in because "so many of his friends prefer it").

Those who had found a bit of success without necessarily being luminaries could appear solo, by dint of their mere-mortal accomplishments. Raymond Ruge, expert yacht designer and racer, got the call from Imperial, which fancied itself a whiskey "for men among men." So what if he looked a little bit like Hitler? Bob Hall, an aeronautical engineer for the Navy, lent his image to a Velvet tobacco ad (Velvet of course being the "aged-in-wood and flavored with pure maple sugar" tobacco). So what if he appeared to be somewhat unhinged? And one look at J. W. "Bub" Evans, "Flying Rancher from Texas," was all it took to convince you that Camel was the only smoke to choose. So what if he was actually just a male model?

What really paid the bills was the celebrity endorser: Rex Harrison is sitting at his piano, he's in a tux, he's preparing for a night on the town. The Lucky Strike people have somehow managed to snap a quick candid and quote the star of stage and screen as saying: "I smoke Luckies — they're mild and smooth." Dean Martin and Jerry Lewis appear in their sailor costumes, hammering out a routine for *Sailor Beware*, their upcoming Paramount release. They don't actually go on record as being Chesterfield smokers, but Pauline Kessinger, manager of the Café Continental, is superimposed alongside them certifying that "Chesterfield is our largest selling cigarette by three to one." The message is clear: if you like Dino and Jerry (or Pauline), you should smoke Chesterfields. Even those famous just for being famous — the Paris Hiltons of yore — were fair game. Smirnoff featured a supposedly glamorous shot of Zsa Zsa Gabor with this pull quote: "Don't Darling Me If It's Not Smirnoff." Message received.

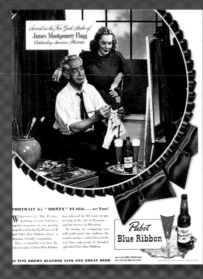

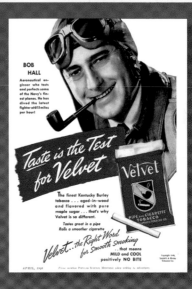

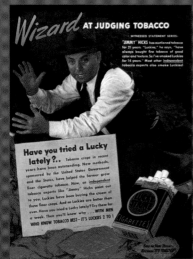

Studies suggest that compared with the influence of the effect of parents, peers, and other environmental influences, "the impact of the media on young people's drinking behavior is relatively weak."

In 1492, Columbus reported that he encountered the natives of the West Indies "drinking smoke."

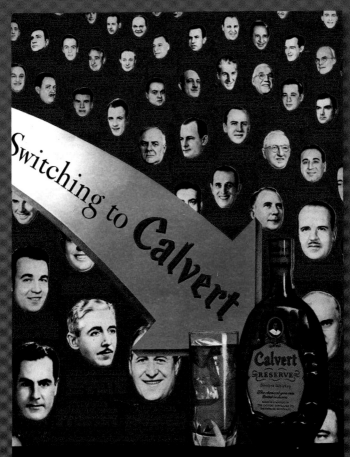

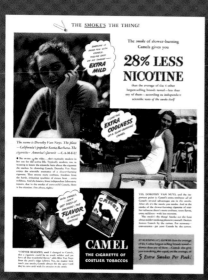

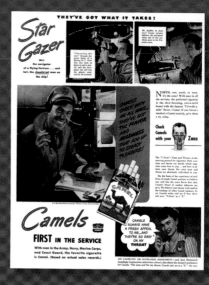

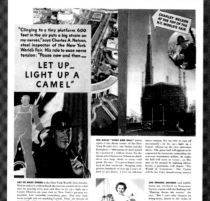

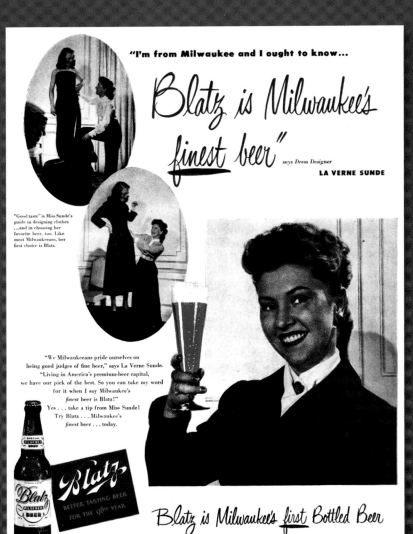

"I'm from Milwaukee and I ought to know...

Blatz is Milwaukee's finest beer"

says Dress Designer
LA VERNE SUNDE

"Good taste" is Miss Sunde's guide in designing clothes ...and in choosing her favorite beer, too. Like most Milwaukeeans, her first choice is Blatz.

"We Milwaukeeans pride ourselves on being good judges of fine beer," says La Verne Sunde. "Living in America's premium-beer capital, we have our pick of the best. So you can take my word for it when I say Milwaukee's *finest* beer is Blatz!"

Yes . . . take a tip from Miss Sunde! Try Blatz . . . Milwaukee's *finest* beer . . . today.

Blatz
BETTER TASTING BEER
FOR THE 98TH YEAR

Blatz is Milwaukee's first Bottled Beer

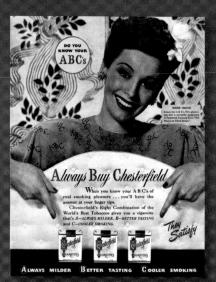

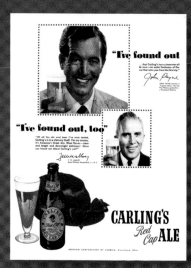

Turn-of-the-century tobacco magnate James Buchanan Duke posted company agents at Ellis Island in New York harbor, the first stop for millions of immigrants to the United States. Every man who entered was given a bag of free cigarettes.

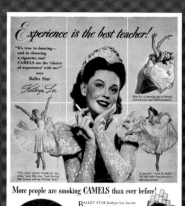

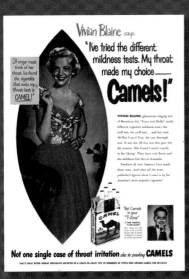

Some translated terms for "hangover" are "wailing of cats" (German), "out of tune" (Italian), "woody mouth" (French), "workmen in my head" (Norwegian), and "pain in the roots of my hair" (Swedish).

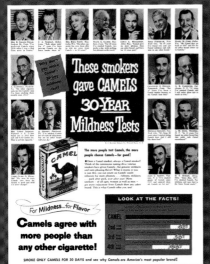

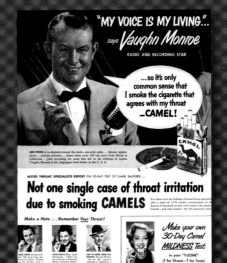

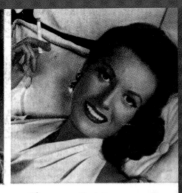

them all
, Camel!
ls agree

Maureen O'Hara "I found it's true — no other cigarette is so genuinely mild, yet so wonderfully rich-tasting as Camel!"

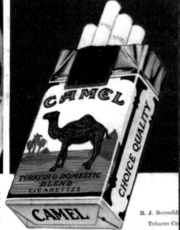

"Since I
d smok-
Camels
pack."

CAMEL

TURKISH & DOMESTIC BLEND CIGARETTES

CHOICE QUALITY

R. J. Reynolds
Tobacco Co
Winston-Salem, N. C

g, yet so mild!

Carbohydrate-focused diets tend to forbid alcohol. Although gin and vodka have no carbs, other forms of alcohol do, and all alcohol provides unnecessary calories that stimulate appetite.

"You might say I'm careful, that's why I say Chesterfields SATISFY me!"

Risë Stevens

METROPOLITAN OPERA'S
WORLD FAMOUS
CARMEN

SATISFY YOURSELF

...like Risë Stevens, that Chesterfields are

A **ALWAYS MILDER**
B **BETTER TASTING**
C **COOLER SMOKING**

THE RIGHT COMBINATION...
WORLD'S BEST TOBACCOS

ALWAYS BUY CHESTERFIELD

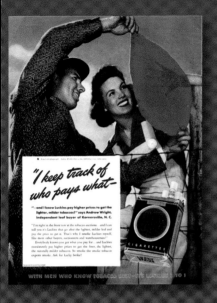

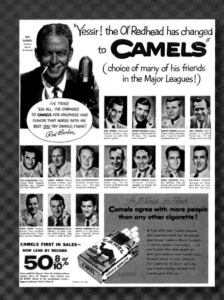

In 1957 Gallaher, a British tobacco company, ran their "You're Never Alone With a Strand" ad campaign. In the TV spot, a solitary soul walks rainy streets. The ad was well-received, but didn't exactly present a positive association. The brand died quickly.

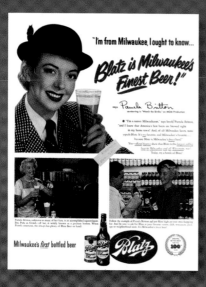

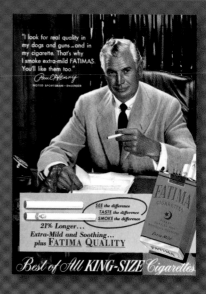

Among the factors that influence blood alcohol levels after a few drinks are body weight, gender, genetics, amount of food in the stomach, rate of drinking, presence of other drugs that affect alcohol metabolism, and overall health.

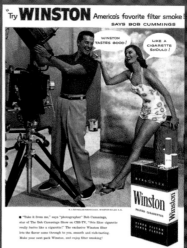

 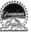
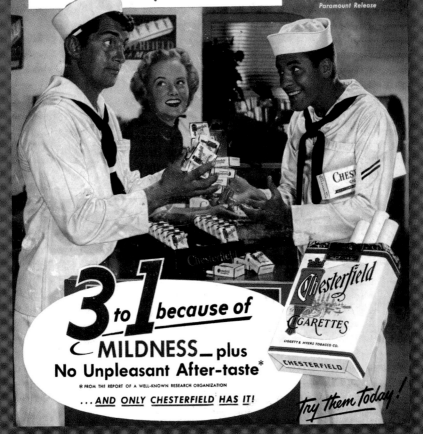

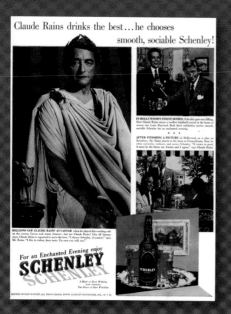

In 1951 the animated titles that open *I Love Lucy* each week feature stick figures of Lucy and Desi climbing a giant pack of Philip Morris cigarettes. The show is rated #1 for four of its first six full seasons.

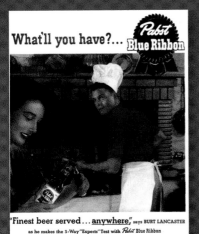
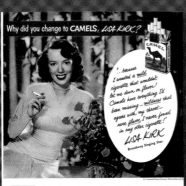
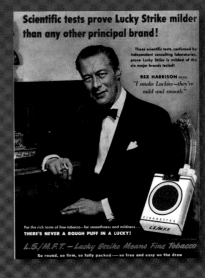
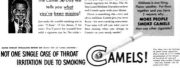
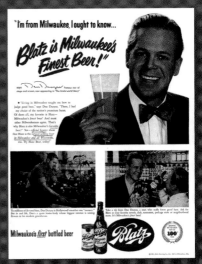

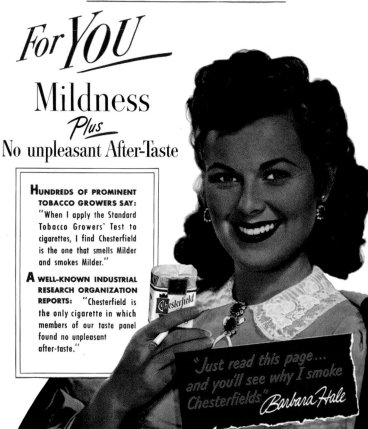

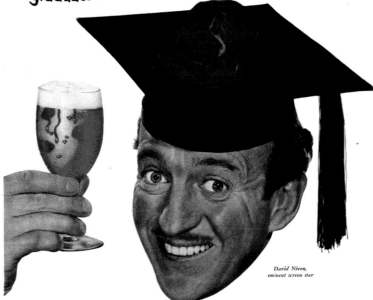
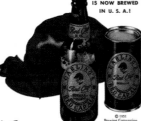

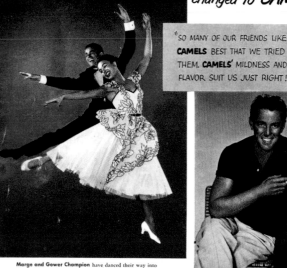
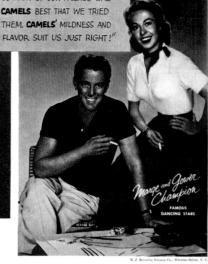

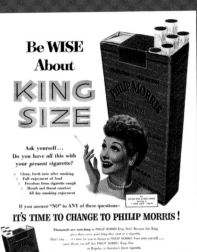

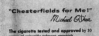
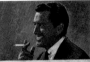
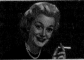
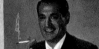

F. Scott Fitzgerald wrote all of *Tender is the Night* while drunk. He later said it would have been a better book if he had been sober.

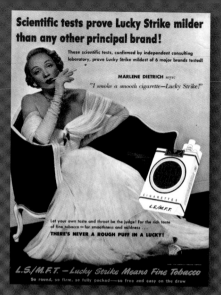

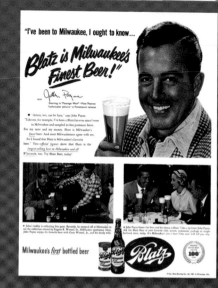

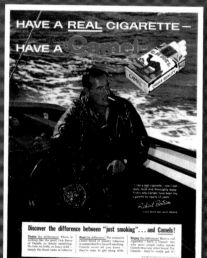

Walter Breuning of Great Falls, Montana, could have been a poster boy for the cigar industry. He finally did quit smoking cigars, but he was ninety-nine at the time and it was only because he couldn't afford them anymore. For Walter's 108th birthday a cigar lover sent him two dozen Cuban cigars, and he got right back on the horse.

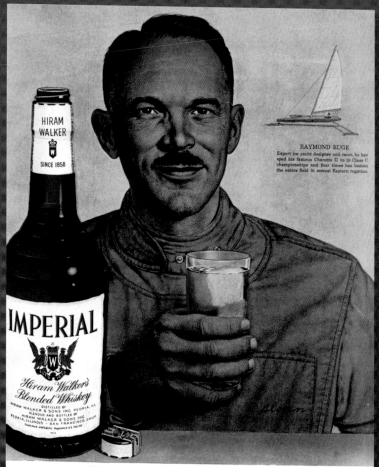

RAYMOND RUGE
Expert ice yacht designer and racer, he has sped his famous Charette II to 10 Class C championships and four times has beaten the entire field in annual Eastern regattas.

FOR MEN AMONG MEN, THERE IS A WHISKEY AMONG WHISKIES — IMPERIAL

Man, this is <u>whiskey</u>!

Made by Hiram Walker to taste as a great whiskey should

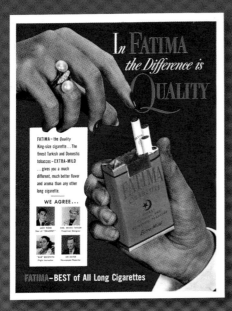

In FATIMA the Difference is QUALITY

FATIMA – the Quality King-size cigarette... The finest Turkish and Domestic tobaccos – EXTRA-MILD ...gives you a much different, much better flavor and aroma than any other long cigarette.

WE AGREE...

FATIMA – BEST of All Long Cigarettes

"I distrust a man who says when. If he's got to be careful not to drink too much, it's because he's not to be trusted when he does."
—Sydney Greenstreet, *The Maltese Falcon*

Charles Lindbergh pointedly lit up during a dinner to honor his trans-Atlantic flight because he felt that the Temperance movement was starting to associate his name to their cause. He didn't want to be anybody's "tin saint."

To Your Health
Pure & Medicinal Vice

Here's a rule I recommend: Never practice two vices at once.
—Tallulah Bankhead

Light an [...] instead of a throat treatment!

Early on, vices were not just tolerated — they were actually considered salutary. The up-for-anything ancient Greeks poured wine directly into wounds, believing it had healing properties. In 1571 German doctor Michael Bernhard Valentini published *Polychresta Exotica* (Exotic Remedies), which stated that tobacco smoke would cure colic, nephritis, hysteria, hernia, and dysentery. In sixteenth century England, what American colonists would later call the "bewitching vegetable" was prescribed for toothache, falling fingernails, worms, bad breath, lockjaw, and cancer. During the Great Plague, intake of tobacco was thought to be a protection against the terrifying contagion in the air. Doctors always kept their pipes lit to ward off the germs of those they were treating. In *The Anatomy of Melancholy*, Robert Burton summed up the warmth of feeling for the curative powers of tobacco in 1621, saying: "Tobacco, divine, rare superexcellent tobacco, which goes far beyond all panaceas, potable gold and philosopher's stones, a sovereign remedy to all diseases."

Pliny the Elder weighed in on booze early when he said wine "invigorates the body." Alcohol was referred to by thirteenth-century doctors as *aqua vitae*, or the water of life, and was prescribed for all manner of physical troubles. (Into the late 1950s, alcohol was still prescribed for heart ailments, anxiety, and stress, even problems with conception). Whiskey was prescribed for laryngitis, aging, "the trembles, the slows, the puking fever," and "the tires;" booze was used, in large amounts, as anesthetic for surgery. At the turn of the century, liquor company promos pushed alcohol as healthy in the sense that it was better for you than opium, the hip addiction among respectable women.

As more and more troubling facts about these, our most precious vices, have been revealed the take on how and why they are good for us has changed. This is mostly reflected in advertising, whose influence and ubiquity rose alongside the statistics. Ads in the 1933 *New York State Journal of Medicine* claimed that Chesterfield cigarettes were "just as pure as the water you drink." The same year

The Journal of the American Medical Association began running cigarette ads, and went on running them for twenty years.

In 1942 Brown & Williamson ads claimed that Kools would keep the head clear and protect against colds. At this point, a war was still on, and no one wanted to hear anything disturbing. Paul Jones American Blended Whiskey's ad boasted of its "Zestful Dryness" — just the thing when the newsreels are getting you down.

A 1946 RJ Reynolds spot famously claimed that "More Doctors Smoke Camels." That same year a *Newsweek* article stated that "sipping a highball while smoking was recommended for smokers suffering from heart disease by a prominent health specialist last week." The specialist cited was Dr. William D. Stroud, professor of cardiology at the University of Pennsylvania Graduate School of Medicine.

When health risk findings became too pronounced to ignore, the tobacco companies' strategies changed. Some ads concentrated on filters and protections instead of denying the health risks. Lorillard introduced the "Micronite" filter in its Kent cigarettes. The Micronite was said to offer "the greatest health protection in cigarette history." Liggett and Myers promoted its "alpha cellulose" filter, apparently hoping a Flash Gordon-esque name would do the trick.

Other ads simply ignored the health angle, emphasizing instead taste, purity, and mildness. Marlene Dietrich appeared in a Lucky Strike ad that declared, "Scientific tests prove Lucky Strike milder than any other principal brand!" John Wayne, Alan Ladd, Maureen O'Hara, and Brian Keith all appeared in support of Camel's assertion that "no other cigarette is so rich-tasting, yet so mild!" A Salem ad claimed its "special High-Porosity Paper 'Air-Softens' every puff." No one wanted to hear the bad news, so advertisers created a fantasy world to keep smokers buying.

Liquor was not under siege the way tobacco was, but there were still mild health concerns to address. PM Deluxe whiskey promoted its "clear clean taste" by showing a cute animated bee extracting honey from a flower. The PM drinker could then feel like drowning his sorrows was just as natural as a bee's instincts (plus the kids, i.e. future buyers, loved it). Ballantine Ale had only to say "Purity, body, and flavor" in its ads to communicate the message that their beer was good *and* good for you. Imperial Whiskey decided not to dance around the subject: "Eighty-eight years of fine whiskey-making makes this whiskey *good*" went the tagline. It's good. So drink it. Who can argue with that?

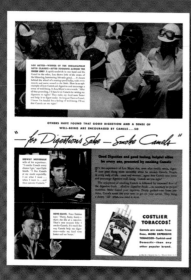

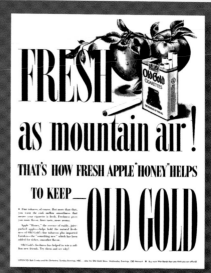

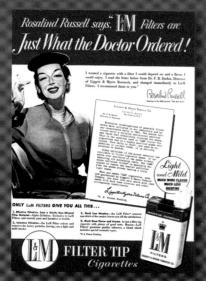

Alcohol increases bathroom breaks by affecting the anti-diuretic hormone of the pituitary gland.

 Three rings wherever you go...

one ring for **purity** a second for **body** a third for **flavor**

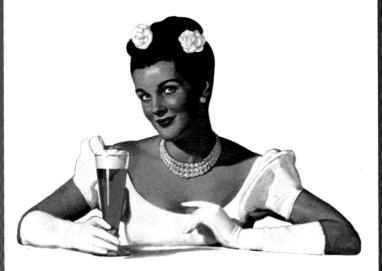

You'll like
BALLANTINE ALE

America's largest selling Ale

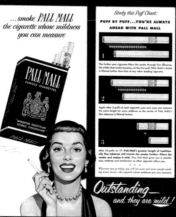
Sponsor RJ Reynolds stipulated that John Cameron Swayze have a burning cigarette visible whenever he was on camera during the 1950s broadcast "The Camel News Caravan."

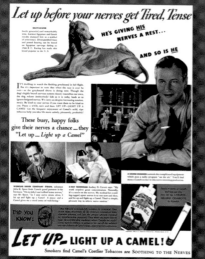

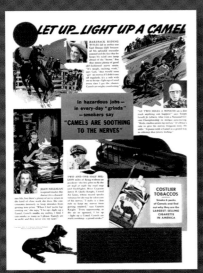
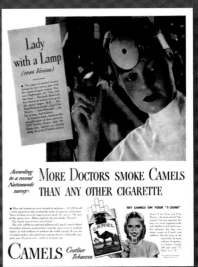
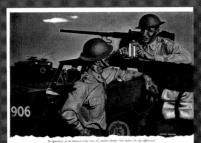
In adults, one ounce of 80 proof
(40 percent) alcohol is generally
metabolized in about an hour.

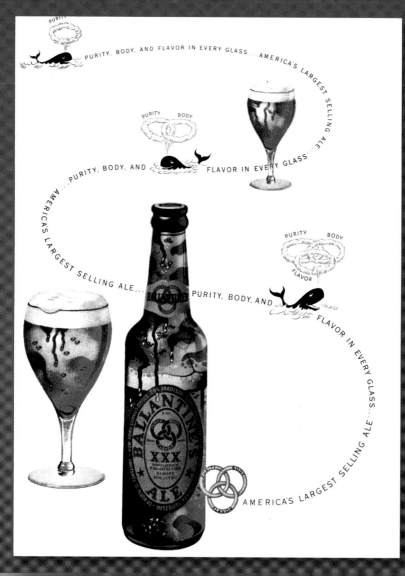

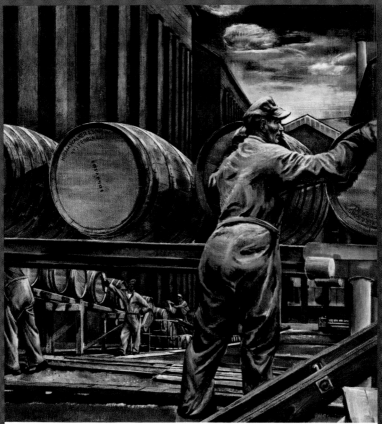

"Aged Whiskey Leaving the Rackhouses"—painted at the distillery by the famous artist, Zoltan Sepeshy

88 years at fine whiskey-making

makes this whiskey <u>good</u>

IMPERIAL

Hiram Walker's Blended Whiskey

86 proof. The straight whiskies in this product are 4 years or more old. 30% straight whiskey. 70% grain neutral spirits. Hiram Walker & Sons Inc., Peoria, Ill.

A blood-alcohol level of .08 percent (the legal limit for DWI in NY) means .08 grams of ethanol in 100 milliliters of blood. Nothing reduces your BAC except time. Sleep, coffee, a cold shower, fresh air or exercise will not affect how fast your liver breaks down alcohol and passes it out of your body.

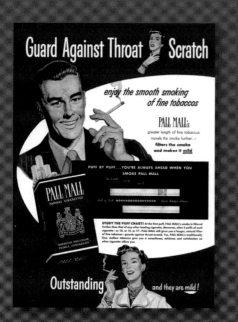

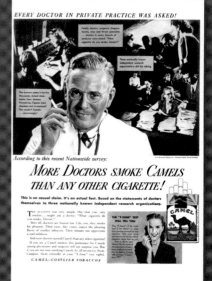

A special kind of refreshment
...from the land of sky blue waters!

Hamm's

We hope these five bottles (and the glass) make you thirsty. Each one, and all the millions like them, contains a special kind of refreshing flavor captured in the land of sky blue waters. Try it!—you'll discover why Hamm's is the most popular beer of all in the broad area where it is sold. Just say the word—"Hamm's"—the one and only Hamm's Beer.

Always the same refreshing flavor . . . glass after glass after glass!

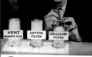

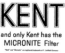
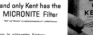

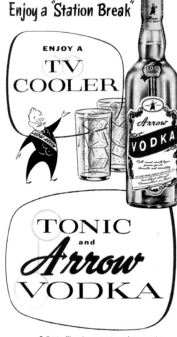
The average smoking prevalence among medical students at the Johns Hopkins medical school was 65 percent for the years 1948–51. By the 1980s the maximum prevalence in medical school surveys was less than 3 percent. Smoking prevalence among U.S. physicians dropped from 53 percent in 1955 to 3 percent in 1993.

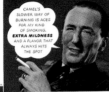

Caffeine does very little to counteract the effects of alcohol. Estimates say it would take up to twenty gallons of coffee to sober up a severely intoxicated person.

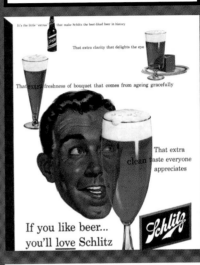
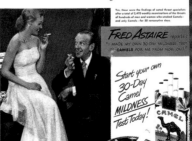

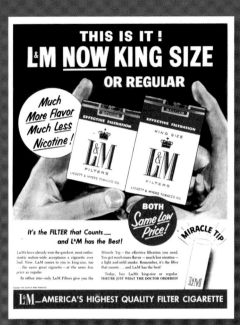

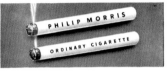
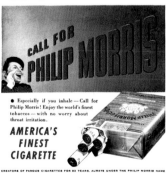

America's two most popular medical shows in 1969, *Ben Casey* and *Dr. Kildare*, were both sponsored by tobacco companies.

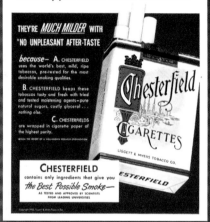

You **GET OUT** of a Cigarette just what **GOES INTO** it!

That's why you should smoke Chesterfields—

THEY'RE *MUCH MILDER* WITH "NO UNPLEASANT AFTER-TASTE

because — **A.** CHESTERFIELD uses the world's best, mild, ripe tobaccos, pre-tested for the most desirable smoking qualities.

B. CHESTERFIELD keeps these tobaccos tasty and fresh with tried and tested moistening agents—pure natural sugars, costly glycerol . . . nothing else.

C. CHESTERFIELDS are wrapped in cigarette paper of the highest purity.

WHEN THE RIGHT OF A WELL-KNOWN RESEARCH ORGANIZATION

Chesterfield
CIGARETTES
LIGGETT & MYERS TOBACCO CO.

CHESTERFIELD
contains only ingredients that give you
the Best Possible Smoke—
AS TESTED AND APPROVED BY SCIENTISTS FROM LEADING UNIVERSITIES

Copyright 1952, Liggett & Myers Tobacco Co.

BUY MORE WAR BONDS!

MEDICAL AUTHORITIES KNOW THIS ONE IS SUPERIOR— PHILIP MORRIS

Scientifically proved less irritating to the nose and throat

WHEN SMOKERS CHANGED TO PHILIP MORRIS, SUBSTANTIALLY EVERY CASE OF IRRITATION OF NOSE OR THROAT — DUE TO SMOKING — CLEARED UP COMPLETELY, OR DEFINITELY IMPROVED!

That is from the findings of distinguished doctors, in clinical tests of men and women smokers —reported in an authoritative medical journal. Solid *proof* that this finer-tasting cigarette *is less irritating* to the nose and throat!

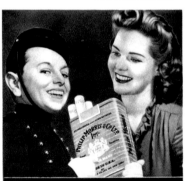

CALL FOR PHILIP MORRIS
America's *FINEST* Cigarette

The frontal brain areas (i.e. the prefrontal cortex) control restraint in human behavior. Alcohol keeps these brain areas from restraining behavior. Inhibitions are lowered, and things happen that you hear stories about but don't remember.

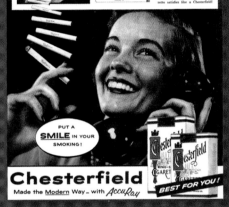
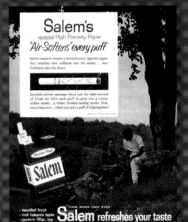

Cigarettes manufactured in the United States increased from 4 billion in 1900 to an estimated 720 billion in 2000.

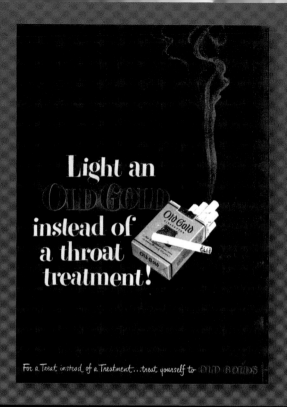

The University of Michigan's "Monitoring the Future" project indicated the following prevalence of alcohol among teenagers: 43 percent of eighth-graders, 65 percent of tenth-graders, and 73 percent of twelfth-graders. Respondents who said they had "been drunk" in the past 30 days: 8 percent of eighth-graders, 24 percent of tenth-graders, and 32 percent of twelfth-graders. (September 16, 2002)

Millions of bottles are bought
by men who like that

clear
clean
taste

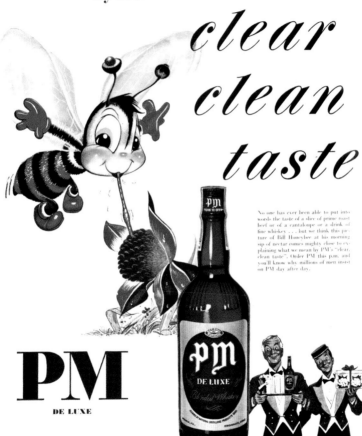

No one has ever been able to put into words the taste of a slice of prime roast beef or of a cantaloupe or a drink of fine whiskey . . . but we think this picture of Bill Honeybee at his morning sip of nectar comes mighty close to explaining what we mean by PM's "clear, clean taste". Order PM this p.m. and you'll know why millions of men insist on PM day after day.

PM
DE LUXE

pm
DE LUXE
Blended Whiskey

National Distillers Products Corporation, New York, N. Y. Blended Whiskey. 86 Proof. 67½% Grain Neutral Spirits.

IN A CIGARETTE

THE SMOKE'S THE THING!

THE SMOKE OF SLOWER-BURNING CAMELS GIVES YOU

EXTRA MILDNESS, EXTRA COOLNESS, EXTRA FLAVOR, AND____

28%

LESS NICOTINE

than the average of the 4 other of the largest-selling cigarettes tested___less than any of them___according to independent scientific tests of the smoke itself

By burning 25% slower

than the average of the 4 other largest-selling brands tested—slower than any of them—Camels also give you a smoking *plus* equal, on the average, to

5 EXTRA SMOKES PER PACK!

WHEN you get right down to it, a cigarette is only as flavorful—only as cool—only as mild—as *it* smokes. The smoke's the thing!

Obvious—yes, but important—all-important because what you get in the smoke of your cigarette depends so much on the way your cigarette burns.

Science has pointed out that Camels are definitely slower-burning (*see left*). That means a smoke with more mildness, more coolness, and more flavor.

Now—Science confirms another important advantage of slower burning . . . of Camels.

Less nicotine—in the smoke! Less than any of the 4 other largest-selling brands tested—28% less than the average!

Light up a Camel . . . a s-l-o-w-burning Camel . . . and smoke out the facts for yourself. The smoke's the thing!

"SMOKING OUT" THE FACTS about nicotine. Experts, chemists analyze the smoke of 5 of the largest-selling brands . . . find that the smoke of slower-burning Camels contains less nicotine than any of the other brands tested.

R. J. Reynolds Tobacco Company, Winston-Salem, North Carolina

CAMEL—THE SLOWER-BURNING CIGARETTE____

56

A 1943 Philip Morris ad in the *National Medical Journal* reasoned: "'Don't smoke' is advice hard for patients to swallow. May we suggest instead 'Smoking Philip Morris?' Tests showed three out of every four cases of smokers' cough cleared on changing to Philip Morris. Why not observe the results for yourself?"

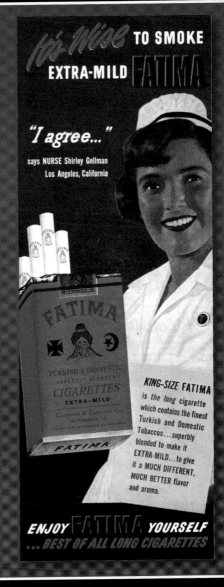

CHAPTER THREE

Just for You
The Gift of Vice

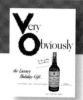

There can't be good living where there is not good drinking.
—Benjamin Franklin

In Corey Ford's 1950 piece for *Esquire*, "The Office Party," he discussed that annual rite of Bacchanalia:

The only thing to do, under these circumstances, is to get good and loaded as fast as possible. After sufficient champagne has been mixed with sufficient rye, the ice is broken, and the participants are not only calling each other by their first names, but are adding certain endearing epithets which they have kept bottled up all year.

You know it's a party when people are using first names.

Holidays and vices are pretty much inseparable — we need our crutches to get through that much family time. In mid-century America, smoking and drinking accoutrements were spot-on gifts. Most everyone had a nip or a drag here and there, and what better way to celebrate the baby Jesus' birthday than with a carton of smokes? The gift-giving possibilities seemed endless. Cigarette case seem a bit impersonal? Add your givee's monogram to it. Or, pick up a cane with a lighter in the handle for that too-too sophisticated Noël Coward-type on your list. If you went to Niagara Falls or Guam you bought the commemorative ashtray, even if you didn't know exactly who would be receiving it. Since most everyone had a wet bar of some sort (during the Polynesian craze in the 1960s, a fully tricked-out tiki bar took over many a rumpus room), booze-related collectibles could bring a smile to the Scroogiest of faces. Moët distributed a champagne-shaped bottle that produced a carousel of cigs when you pulled on the top. You could give that special someone a lighter that looked like a little bar top, complete

with jolly-looking bartender. Liquor companies produced holiday decanters, which were much anticipated and took on a multitude of forms (Jim Beam's being the most varied line), from an armadillo to a slot machine to Madame Butterfly. They were fun to look at, their contents helped you deal with your mother-in-law, and they eventually became prized collectibles.

The Zippo lighter became an icon after its introduction in 1932 by inventor George G. Blaisdell, who liked the name of another recent invention, the zipper. It quickly became the only lighter to have, and its distinctive *plink* upon being snapped open reminds just about every person you ask of a beloved smoking relative. You could not go wrong giving a Zippo, even if the receiver didn't smoke.

Around holiday time, especially Christmas, the liquor and cigarette companies dusted off their celebratory approaches, and visions of increased revenue danced in their heads. Everyone would be drinking and smoking more, and whatever credit the hucksters could take they would. In 1949 the ASR lighter company went straight to the top, depicting Santa lighting up with one of their little beauties. Santa looks jolly (which means drunk, by the way), and points to a bit of graffito that reads: "S.C. loves A.S.R." In another snow-covered plug, Chesterfield big-heartedly wished its potential buyers a Merry Christmas "...and to everybody more smoking pleasure."

Old Gold decided to stick their necks out, touching on holiday stress by depicting a man felled by his own Christmas tree. "Why be Irritated?" asks his lovely significant other, offering him an Old Gold from her pack instead of helping him with the tree situation. This no doubt delivered the niche market of those underneath Christmas trees for the entire season.

Father's Day was another heavy advertising season, and RJ Reynolds got right on it with a cross-promotional ad featuring a choice of RJR products Dad might get a kick out of: a case of Camels; a case of Cavaliers (the "extremely mild" alternative to Camels, and an extreme failure); or that crank call staple, Prince Albert in a can. What kid wouldn't be thrilled at the world of possibilities?

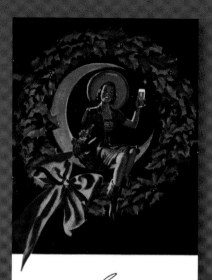

Season's Greetings

A Holiday toast to you
from the National Champion of Quality . . .

The Champagne of Bottle Beer

Brewed and Bottled in Milwaukee Wisconsin Only, by The Miller Brewing Company

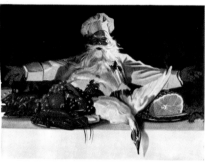

Help Yourself to Good Taste

Hospitality lives in every heart, but Christmas provides a special occasion to express it. When family and friends get together, Christmas is as flavorful as it is gay. The table laden with plump fowl and delicious dressing, cranberry sauce, succulent vegetables, snowflake potatoes with giblet gravy . . . and Budweiser! Golden, bubbling, sparkling, foaming . . . Budweiser! It tells you with every sip why it is something more than beer . . . a tradition in hospitality.

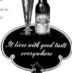

It lives with good taste everywhere

Budweiser

ANHEUSER-BUSCH · · · SAINT LOUIS

In 1911, the year the Supreme Court broke up the American Tobacco Company's monopoly, the conglomerate produced 10 billion cigarettes.

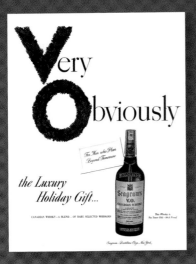
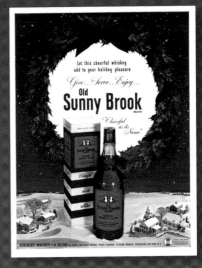
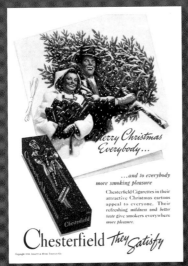
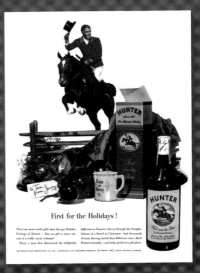

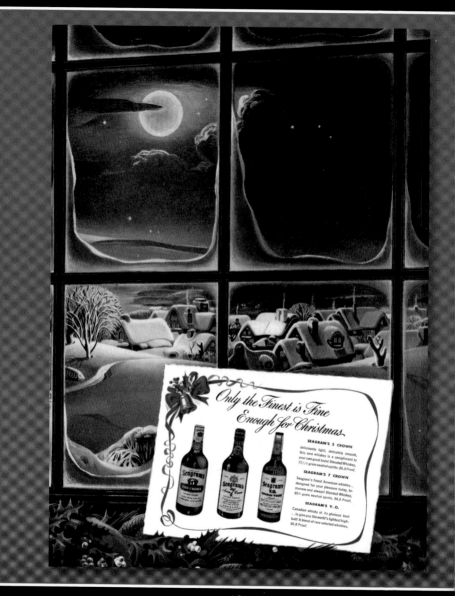

Only the Finest is Fine Enough for Christmas

SEAGRAM'S 5 CROWN

deliciously light, delicately smooth, this rare whiskey is a compliment to your own good taste! Blended Whiskey. 72½% grain neutral spirits. 86.8 Proof.

SEAGRAM'S 7 CROWN

Seagram's finest American whiskey... designed for your pleasure today, tomorrow and always! Blended Whiskey. 65% grain neutral spirits. 86.8 Proof.

SEAGRAM'S V.O.

...Canadian whisky at its glorious best ...to give you the world's lightest highball! A blend of rare selected whiskies. 86.8 Proof.

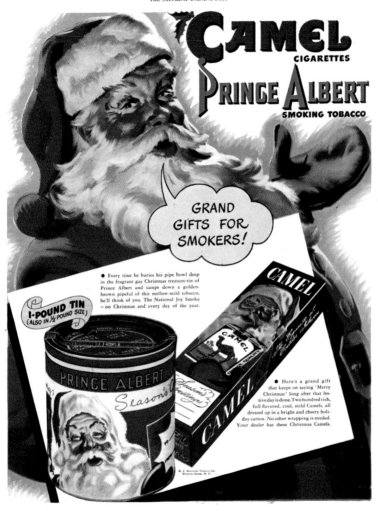

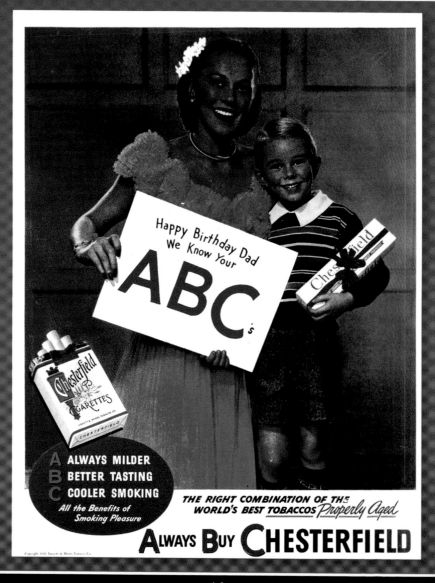

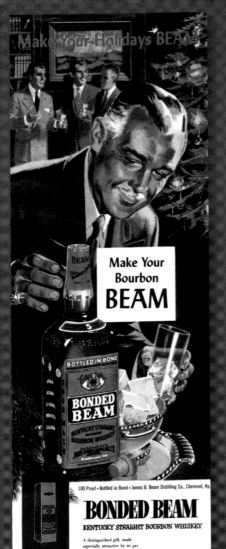

Make Your Bourbon **BEAM**

BONDED BEAM

KENTUCKY STRAIGHT BOURBON WHISKEY

100 Proof • Bottled in Bond • James B. Beam Distilling Co., Clermont, Ky.

A distinguished gift, made especially attractive by its gay Christmas carton.

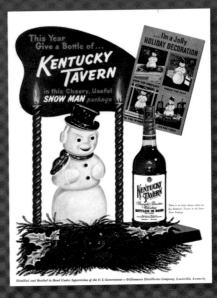

This Year Give a Bottle of... **KENTUCKY TAVERN** in this Cheery, Useful SNOW MAN package

...Im a Jolly HOLIDAY DECORATION

Distilled and Bottled in Bond Under Supervision of the U.S. Government — ©Glenmore Distilleries Company, Louisville, Kentucky

Bourbon is the official spirit of the United States, by Act of Congress.

Sloe gin is a deceptively named booze. It's not gin at all, but a liqueur flavored with sloe — a small, sour, blackish fruit of the blackthorn shrub.

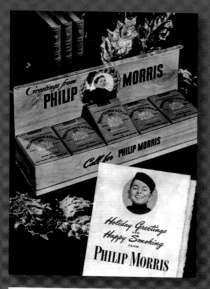

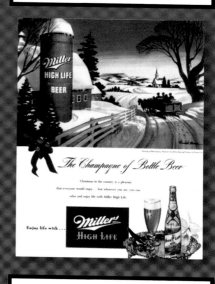

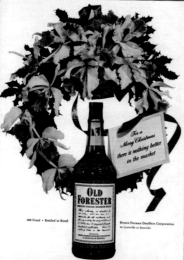

Benjamin Franklin said: "Drinking does not improve our faculties, but it enables us to use them," and "Beer is proof that God loves us and wants us to be happy."

Total world cigarette production was 5.45 trillion in 1991, representing a 300 percent total increase and a 50 percent per capita increase since 1950 — enough to supply every person on earth with three cigarettes per day.

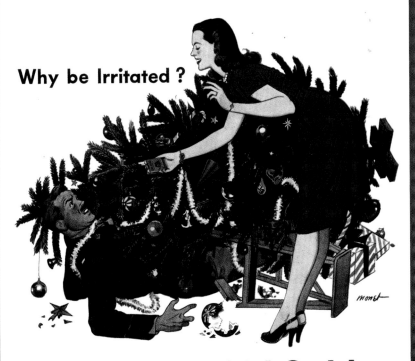

Why be Irritated?

Light an **Old Gold**

Apple "Honey" helps guard O.Gs. from <u>Cigarette Dryness</u>

You're right up with the best in smoking pleasure — when you've got Old Golds! For here's a superlative blend of choice tobaccos — with a touch of rare Latakia tobacco for *extra flavor*. Plus the special moisture-protecting agent we call "Apple "Honey", made from the juice of fresh apples. This helps hold in the natural moisture, *helps prevent cigarette dryness*. Just ask for Old Golds . . . every time.

BUY VICTORY BONDS AND HOLD THEM

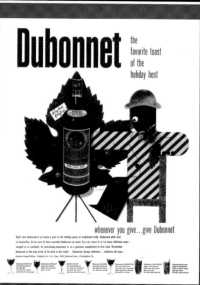

Dubonnet

the favorite toast of the holiday host

whenever you give...give Dubonnet

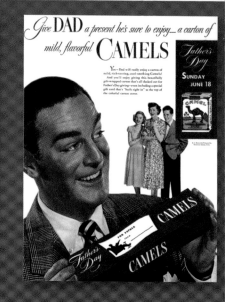

Give DAD *a present he's sure to enjoy_ a carton of* mild, flavorful CAMELS

Father's Day

SUNDAY
JUNE 18

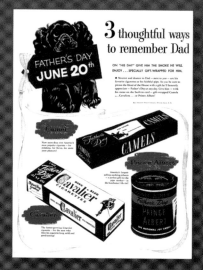

FATHER'S DAY
JUNE 20th

3 thoughtful ways to remember Dad

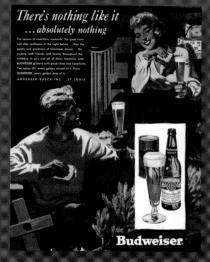

There's nothing like it
...absolutely nothing

ANHEUSER-BUSCH, INC. · ST. LOUIS

Budweiser

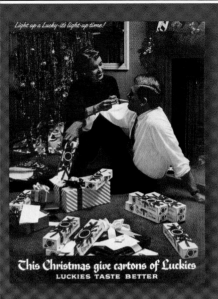

This Christmas give cartons of Luckies
LUCKIES TASTE BETTER

World War II-era Major Grayson MP Murphy said: "In an hour of stress, a smoke will uplift a man to prodigies of valor; the lack of it will sap his spirit."

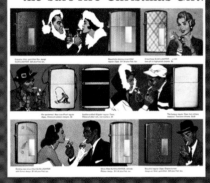

Give Zippo...
the sure-fire Christmas Gift!

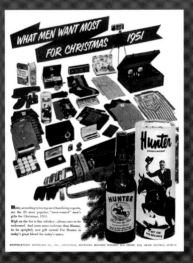

WHAT MEN WANT MOST FOR CHRISTMAS 1951

In ancient India, wives were allowed to smell shared libations as they were passed around but not to actually partake (for mistresses it was fine).

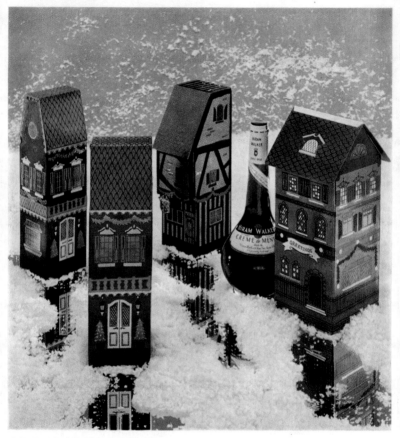

GREAT GIFT IDEA ...

"HOLIDAY HOUSE" GIFT PACKS!

Holiday flattery—in four favorite flavors: Creme de Menthe, Creme de Cacao, Anisette, and Blackberry Flavored Brandy. All by Hiram Walker and each festively packaged in its own charming gift pack. *At no extra charge* . . . and ready for you to give.

CREME DE MENTHE, CREME DE CACAO, ANISETTE, 60 PROOF; BLACKBERRY FLAVORED BRANDY, 70 PROOF
HIRAM WALKER & SONS, INC., PEORIA, ILL.

HIRAM WALKER'S
CORDIALS
A Rainbow of Distinctive Flavors

The cigarette took a while to become popular because the dainty little things were seen as too coarse for women and too feminine for men.

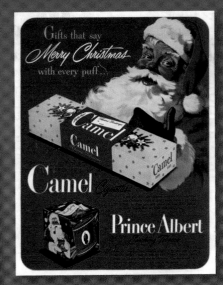

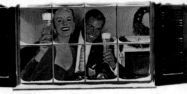

Holidays call for the finer things in life

There's no substitute for the unmistakable quality of Schlitz. It's the genuine premium beer! Brewed for quality... never for price.

 The Beer that Made Milwaukee Famous

© 1955—Jos. Schlitz Brewing Company, Milwaukee, Wis., Brooklyn, N.Y., Los Angeles, Calif.

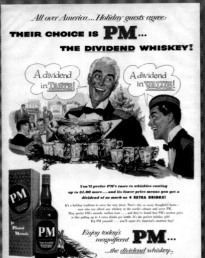

Alcohol was given to Civil War soldiers as an anesthetic during severely painful procedures like bullet removal and amputation.

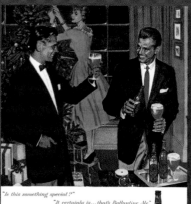
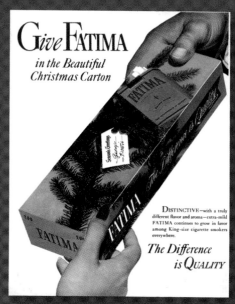

Studies have suggested that a neurochemical abnormality in the mesolimbic dopamine system of the brain leads to alcoholism. Alcohol may help to fix genetic misconnections along this "pleasure pathway," creating a chemical reliance in the drinker. Therefore, if no alcohol is ever introduced to the brain, the disease cannot manifest itself.

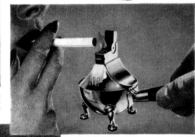

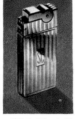

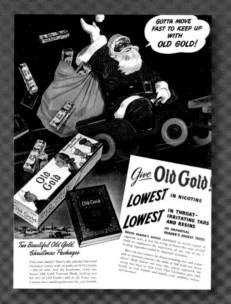

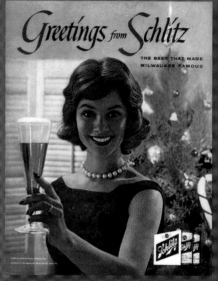

In the United States in 1900, 7.4 pounds of tobacco were consumed per person age 15 years and older: 2 percent as cigarettes, 48 percent as chewing tobacco, 27 percent as cigars, and 19 percent as smoking tobacco (pipe and hand-rolled). By 1952, 12.9 pounds were consumed per person: 81 percent cigarettes, 3 percent chewing tobacco, 10 percent cigars, and 4 percent as smoking tobacco. In 1991, the figure was 5.1 pounds, with 87 percent cigarettes, 9 percent smokeless tobacco, 4 percent cigars, and 1 percent smoking (mostly pipe) tobacco.

Our Christmas
Our tree
Our cigarette

*It's the little things that mean the most.
The carols we sing on Christmas Eve . . .
the star that shines down from our tree . . .
the silent words that pass between us
as we light our Regents. Little things . . .
but Oh, so tender and important to us.*

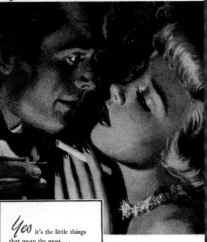

Yes it's the little things
that mean the most . . .
especially in a cigarette.
More care in the selection
of choice tobaccos, better
tailoring, a smart oval shape
in the continental manner.
Added together, these
refinements make Regents a
better tasting cigarette for
people of better taste. Give
the handsome Christmas carton.

*The Luxury Smoke
at Popular Price*

REGENT The Only Really Distinctive Cigarette Gift

In 1812 Lord Byron wrote:
"A woman should never
be seen eating or drinking,
unless it be lobster salad and
Champagne, the only true
feminine & becoming viands."

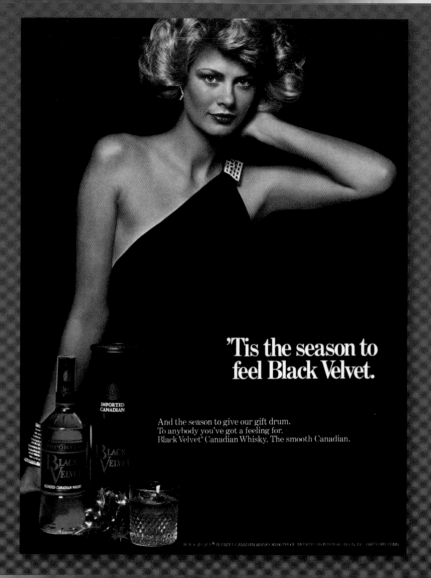

'Tis the season to
feel Black Velvet.

And the season to give our gift drum.
To anybody you've got a feeling for.
Black Velvet® Canadian Whisky. The smooth Canadian.

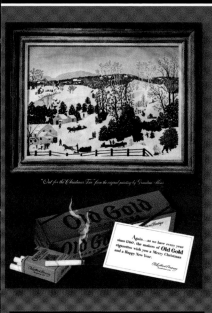

"Out for the Christmas Tree" from the original painting by Grandma Moses

Again...as we have every year since 1760, the smokers of **Old Gold** cigarettes wish you a Merry Christmas and a Happy New Year.

Old Gold Company

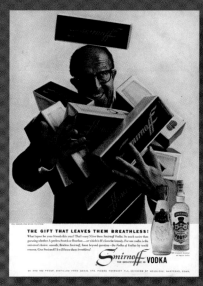

THE GIFT THAT LEAVES THEM BREATHLESS!

Smirnoff

THE GREATEST NAME IN **VODKA**

Lucy Page Gaston was a staunch anti-smoking temperance figure. She identified an element in cigarette smoke, *furfural*, that she said created in smokers an intense thirst that led inescapably to the drinking of alcohol (and then, of course, moral collapse). She also ran for President, listing as one of her qualifications the fact that she looked a little like Abe Lincoln. (The same Honest Abe who said, "It has been my experience that folks who have no vices have very few virtues.")

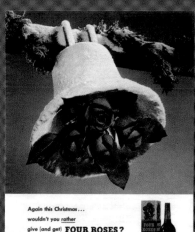

Again this Christmas...
wouldn't you rather
give (and get) **FOUR ROSES**?

Four Roses has long been America's favorite gift whiskey. Fine Blended Whiskey, in attractive gift carton. 90.5 proof, 60% grain neutral spirits. Frankfort Distillers Corporation, N. Y. C.

CHAPTER FOUR

Nothing But the Best
Distinctive Vice

Arrival of the Fashionable Scotch

The greatest minds are capable of the greatest vices as well as of the greatest virtues.
—Descartes

Thousands of years ago, in ancient Mesopotamia, a drudge toiling at one of the temples received a ration of two pints of beer a day, while senior dignitaries received ten — the better to communicate with the gods, or with whomever they stumbled across, really. Alcohol distribution was class-based throughout early history (often in favor of the red-nosed holy man). Like so many things, vices are broken down in a way that makes those who care (or can afford to care) about such things feel more rarified. The name Joe Six-Pack came about because said Joe couldn't afford better beer. Remy Martin makes a neat little cognac they call Louis XIII; it comes in a baccarat crystal decanter and goes for about $120 a shot in chi-chi clubs. Is there any reason to pay that? If it makes you feel rich as Roosevelt, sure.

In the 1940s, 1950s, and 1960s the most reliable approach to selling booze and smokes was very simple: associate with glamour. That's why an ad for Glenmore welcomed "People of Inherent Good Taste." If you somehow felt you were a tasteless slob (and not even the coarsest of palookas thinks that), this was not the scotch for you. Old Hickory bourbon laid claim to being "Observed in the best circles..." and included a well-heeled golfer having a quick nip between putts. Smokers eager to perform well socially were told that "Discriminating people prefer Herbert Tareyton" cigarettes. Du Maurier smokes offered a coy "If you have a taste for luxury do say du Maurier."

It made sense to play up distinction in alcohol and cigarette advertising, since vice had a way of entering into class debates in a multitude of ways. In 1878 Mrs. H. O. Ward, in *Sensible Etiquette of the Best Society Customs, Manners, Morals, and Home Culture, Compiled from the Best Authorities*, gave us a handy primer on how to look down one's nose:

That man is to be pitied who cannot enjoy social intercourse without eating and drinking. The lowest orders, it is true, cannot imagine a cheerful assembly without the attractions of the table, and this reflection alone should induce all who aim at intellectual culture to endeavor to avoid placing the choicest phases of social life on such a basis.

In the early twentieth century, when industry was king and sloth was reviled, smoking was targeted by the boys upstairs to the detriment of the poor schlubs toiling away in the trenches. A 1907 *New York Times* article stated, "Business . . . is doing what all the anti-cigarette specialists could not do." Two titans, Henry Ford and Thomas Edison, expressed a mutual disapproval of smokers. They felt smoking was unclean, dangerous and — most importantly — led to break-taking. In a 1914 letter to Ford, Edison wrote "I hire no person who smokes." Hudson Maxim, munitions builder and inventor of the first machine gun, wrote that "with every breath of cigarette smoke they inhale imbecility and exhale manhood . . . the cigarette is a maker of invalids, criminals and fools — not men."

One of the factors that supported Prohibition was the old-stock White Anglo Saxon population's desire to control hard-drinking immigrants. The Irish and Italians were working hard and rising fast; it was felt that taking away the beer and wine that was so much a part of their respective cultures might take the wind out of their political sails.

In 1904, several women were arrested and even jailed for smoking in public. The 1908 Sullivan Act made it illegal (briefly) for public establishments to allow women to smoke. In 1922, a woman was expelled from Michigan State University for unrepentantly lighting up. This was the new age of women, though, and she took her case all the way to the Supreme Court. She was rebuffed.

But the tobacco companies were more interested in profits than gender politics. The Marlboro "Mild as May" campaign was created in the 1920s to target "decent, respectable" women. "Has smoking any more to do with a woman's morals than has the color of her hair?" asked the campaign. Then Edward Bernays, a public relations whiz for the American Tobacco Company, led women in a 1929 march down Fifth Avenue. The participants proudly clutched their cigarettes, declaring them "torches of freedom."

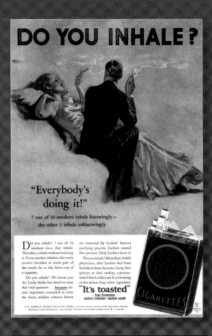

A glossary of terms for those that love their drink: drunkard, inebriate, sot, soak, bibber, bibbler, barfly, dipsomaniac, rummy, guzzler, swiller, soaker, sponge, boozer, boozehound, lush, souse, wino, alchy, juicehead, juicer, hooch hound, gin hound, swillbelly, swillpot, stew, stewbum, elbow-bender.

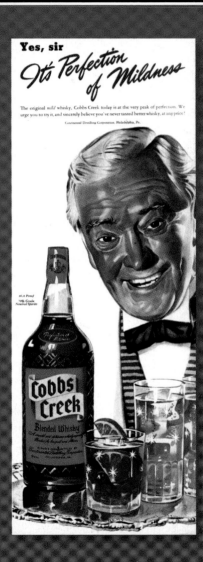

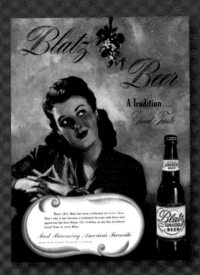

Blatz Beer

A Tradition...
Good Taste

Since 1851, Blatz has been celebrated for Good Taste. That's why it has become a traditional favorite with those who appreciate the finer things. On a holiday, or any day, it's always Good Taste to serve Blatz.

Fast Becoming America's Favorite

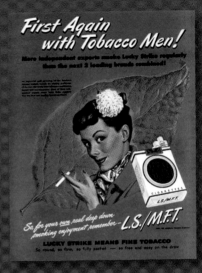

First Again with Tobacco Men!

More independent experts smoke Lucky Strike regularly than the next 2 leading brands combined!

So, for your *own* real deep down smoking enjoyment remember — **L.S./M.F.T.**

LUCKY STRIKE MEANS FINE TOBACCO

So round, so firm, so fully packed — so free and easy on the draw

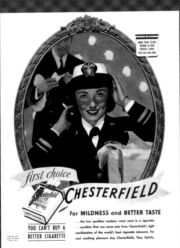

first choice

CHESTERFIELD

For MILDNESS and BETTER TASTE

...the two qualities smokers want most in a cigarette
...qualities that can come only from Chesterfield's right combination of the world's best cigarette tobaccos. For real smoking pleasure buy Chesterfield. They Satisfy.

YOU CAN'T BUY A BETTER CIGARETTE

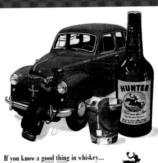

If you know a good thing in whiskey...

you'll instantly recognize the superiority of HUNTER, long famous as America's *luxury* blend. Its flavor is so distinctive that no one has been able to copy it in over 91 years.

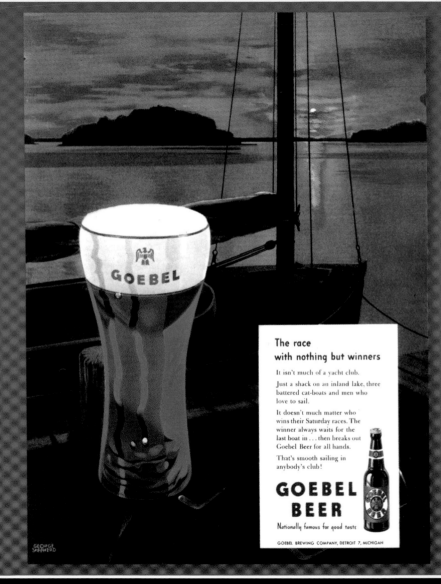

The race
with nothing but winners

It isn't much of a yacht club.

Just a shack on an inland lake, three
battered cat-boats and men who
love to sail.

It doesn't much matter who
wins their Saturday races. The
winner always waits for the
last boat in . . . then breaks out
Goebel Beer for all hands.

That's smooth sailing in
anybody's club!

GOEBEL
BEER

Nationally famous for good taste

GOEBEL BREWING COMPANY, DETROIT 7, MICHIGAN

GEORGE
SHEPHERD

82

One of the strangest juries ever called!...

FLEETWOOD A cleaner, finer smoke

Some groups with high smoking prevalence are unemployed men (44 percent), divorced or separated men (48 percent), psychiatric outpatients (52 percent), psychiatric inpatients (72 percent), and alcoholics (83 percent).

America's Most Distinguished Beer

Schlitz

THE BEER THAT
MADE MILWAUKEE FAMOUS

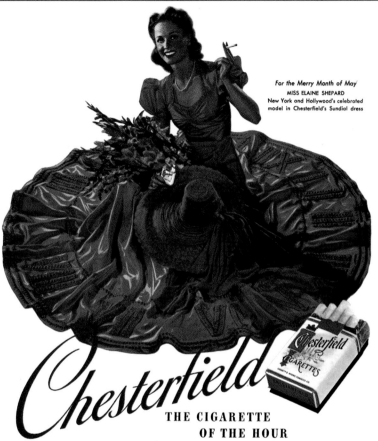

For the Merry Month of May
MISS ELAINE SHEPARD
New York and Hollywood's celebrated
model in Chesterfield's Sundial dress

Chesterfield

THE CIGARETTE
OF THE HOUR

Today more than ever, smokers are turning to
Chesterfield's skillful blend of the world's best ciga-
rette tobaccos. Now is the time for you to light up
and enjoy a Chesterfield...they're **COOLER SMOKING,
BETTER-TASTING AND DEFINITELY MILDER.**

You can't buy a better cigarette

UNMISTAKABLY ASCOT!

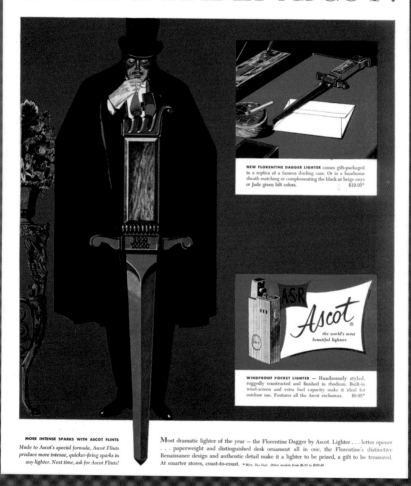

NEW FLORENTINE DAGGER LIGHTER comes gift-packaged in a replica of a famous dueling case. Or in a handsome sheath matching or complementing the black or beige onyx or Jade green hilt colors. $19.95*

WINDPROOF POCKET LIGHTER — Handsomely styled, ruggedly constructed and finished in rhodium. Built-in wind-screen and extra fuel capacity make it ideal for outdoor use. Features all the Ascot exclusives. $9.95*

MORE INTENSE SPARKS WITH ASCOT FLINTS
Made to Ascot's special formula, Ascot Flints produce more intense, quicker-firing sparks in any lighter. Next time, ask for Ascot Flints!

Most dramatic lighter of the year — the Florentine Dagger by Ascot. Lighter . . . letter opener . . . paperweight and distinguished desk ornament all in one, the Florentine's distinctive Renaissance design and authentic detail make it a lighter to be prized, a gift to be treasured. At smarter stores, coast-to-coast. *Mfrs. Tax Incl. Other models from $6.95 to $200.00*

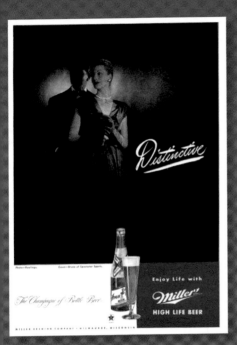

Brewing magnate August Anheuser Busch Jr. bought the St. Louis Cardinals in 1953, and the Cardinals home is still called Busch Stadium. Busch used to like to ride into the park under the power of his famous Budweiser Clydesdales, who were the focus of a very memorable Bud campaign.

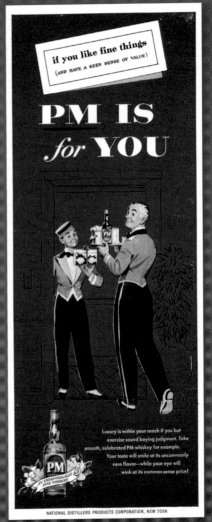

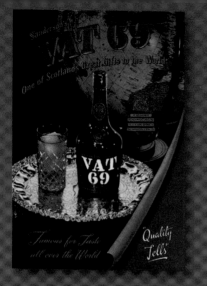

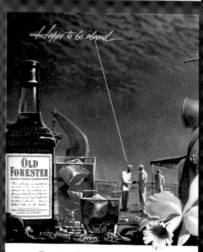

Most U.S. states have a .08 percent Blood-Alcohol-Content (BAC) limit for Driving While Intoxicated. In Australia, Finland, the Netherlands, and Norway, the limit is .05 percent. In Sweden it's .02 percent.

...but
three
on
a
RONSON is good luck!
WORLD'S GREATEST LIGHTER

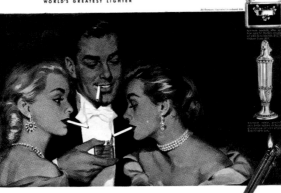

Snap your fingers at that old hoodoo about three on a light! You feel lucky
with a Ronson because nothing is left to chance in making it the finest lighter
possible . . . a lighter designed to serve faithfully under the most exacting
conditions . . . and for an unbelievable number of years. It leads a charmed
life . . . and so do you when you have one. So cast superstition to the wind . . .
light up three, four or more, on a Ronson . . . the world's greatest lighter.
To stay lucky, make sure your lighter has the trademark **RONSON**

Remember! *All lighters work best with Ronsonol Fuel and Ronson Redskin 'Flints'.*

a RONSON is wonderful to give and to own!

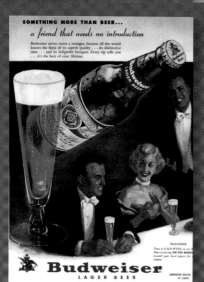
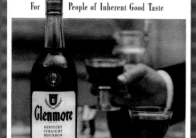
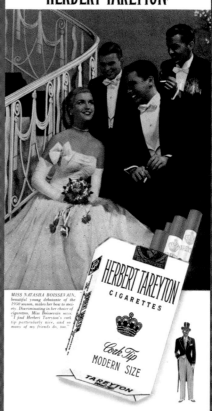

NOTHING—<u>NO</u>, <u>NOTHING</u>—BEATS BETTER TASTE

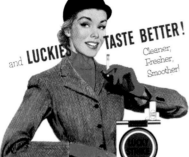

and **LUCKIES TASTE BETTER!**

Cleaner, Fresher, Smoother!

You can even <u>see</u> why Luckies taste better—cleaner, fresher, smoother

Be Happy—**GO LUCKY!**

Boys generally experience far more pressure to drink than girls, and have to learn to handle it much more quickly.

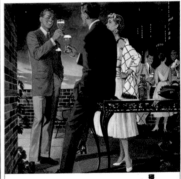

"I had no idea ale was so wonderful."
"It isn't ordinarily; that's *Ballantine Ale*"

BALLANTINE ALE...the light ale America prefers by 4 to 1!

IN MOST OF THE WORLD'S FINEST CLUBS ...
IN <u>ALL</u> OF THE WORLD'S FINEST <u>DRINKS</u> :

GILBEY'S
Spey-Royal
Scotch Whisky

GILBEY'S

Prevalence of smoking among adults peaked at 42.4 percent in 1965.

Discriminating people prefer

HERBERT TAREYTON

...with the genuine cork tip to protect the lips

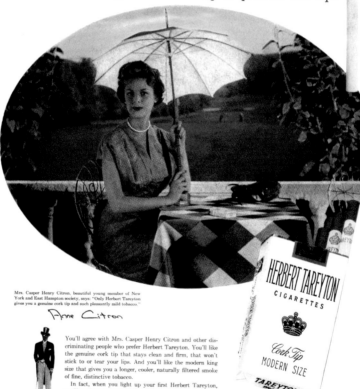

Mrs. Casper Henry Citron, beautiful young member of New York and East Hampton society, says: "Only Herbert Tareyton gives you a genuine cork tip and such pleasantly mild tobacco."

Anne Citron

You'll agree with Mrs. Casper Henry Citron and other discriminating people who prefer Herbert Tareyton. You'll like the genuine cork tip that stays clean and firm, that won't stick to or tear your lips. And you'll like the modern king size that gives you a longer, cooler, naturally filtered smoke of fine, distinctive tobacco.

In fact, when you light up your first Herbert Tareyton, you'll say it's the most enjoyable cigarette you ever smoked!

HERBERT TAREYTON
CIGARETTES

Cork Tip
MODERN SIZE

TAREYTON

Observed in the best circles...

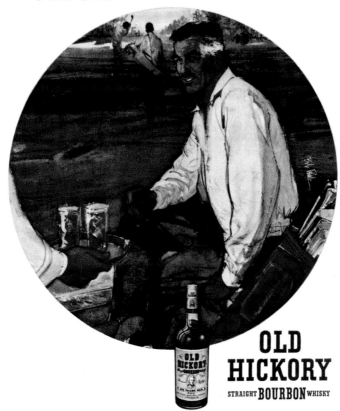

OLD HICKORY

STRAIGHT **BOURBON** WHISKY

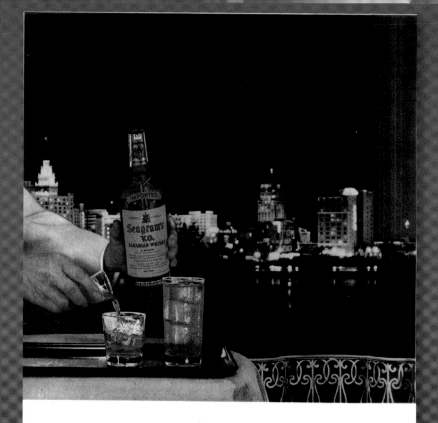

Known by the Company it Keeps

 Seagram's VO

Eleanor Roosevelt has been called "the first lady to smoke in public."

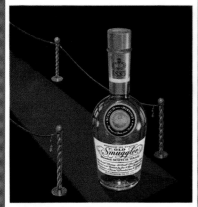

Arrival of the Fashionable Scotch

WHETHER you are meeting Old Smuggler for the first time or the thousandth time, its arrival rightfully rates the "red carpet."

It is what Scotsmen call a *fashionable* Scotch. Because it is developed with patience and scruple—because it is distinguished by great softness and delicacy of flavour—and because it carries on quality traditions that date back to 1835.

The precious character of Old Smuggler prompts men to pay it a spontaneous and unique tribute when it is poured: "Careful, don't waste a drop—that's Old Smuggler."

If you have not yet enjoyed the superb delight of Old Smuggler, why not ask for it by name the next time? You will be richly rewarded. Please take another look at the bottle to fix it firmly in your memory.

Distilled, Blended and Bottled in Scotland
Imported by
W. A. TAYLOR & COMPANY, N. Y., N. Y.
Sole Distributors for the U. S. A.
BLENDED SCOTCH WHISKY • 86 PROOF

OLD Smuggler
SCOTCH with a History

Anthropological studies have placed the earliest accounts of drinking alcohol as early as 10,000 years ago.

Escape from the commonplace

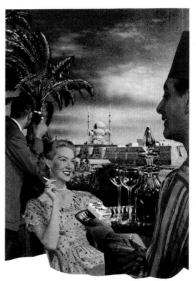

Enjoy something different
...try **MARLBORO**
CIGARETTES

**Finer taste, superior mildness—a
luxury in smoking unmatched
by any other cigarette!**

When smoking has stopped being a pleasure and becomes only a habit, it's time to freshen up your taste. So if you need a change, *remember* . . .

IVORY TIPS
PLAIN ENDS
BEAUTY TIPS (RED)

Marlboros are _better_ in every way
for those who smoke throughout the day!

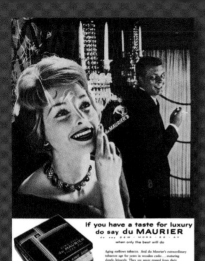

More and more cars are being manufactured without ashtrays and cigarette lighters. Models without standard ashtrays and lighters include all Dodge and Chrysler minivans, Saturn cars, the Cadillac Seville, the Infinity G20, and the Acura TL.

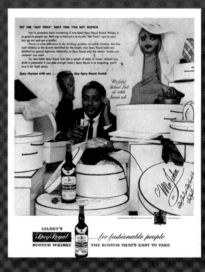

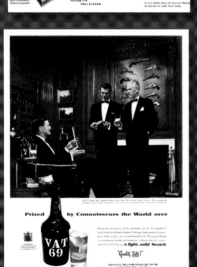

Some studies have found that those who consume small to moderate amounts of alcohol have lower death rates than those that don't drink at all.

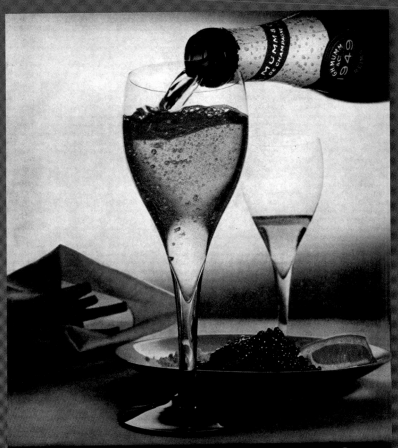

MUMM'S

THE WORD FOR CHAMPAGNE

Cordon Rouge and Extra Dry · The classic champagnes of France

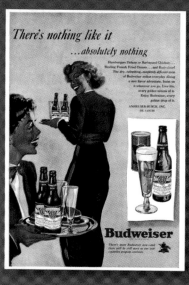

There's nothing like it
...absolutely nothing

Budweiser

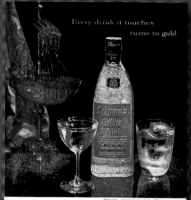

Every drink it touches
turns to gold

So extra dry...it's golden

The golden glow in Seagram's gin is Nature's own sign of mellow perfection. Magnificent in martinis—supremely smooth just poured over ice! And dry? This is golden gin—anything dry-er simply wouldn't pour!

Say Seagram's and be Sure
Seagram's Golden Gin *the world's Perfect G*

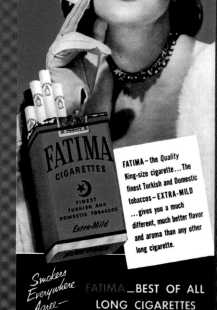

L FATIMA
the Difference is QUALITY

FATIMA—the Quality King-size cigarette...The finest Turkish and Domestic tobaccos—EXTRA-MILD ...gives you a much different, much better flavor and aroma than any other long cigarette.

FATIMA
CIGARETTES
FINEST TURKISH AND DOMESTIC TOBACCOS
Extra-Mild

Smokers Everywhere Agree—

FATIMA—BEST OF ALL LONG CIGARETTES

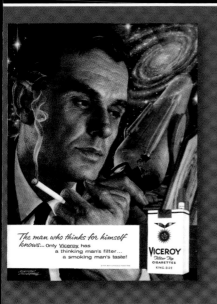

The man who thinks for himself *knows*... Only **Viceroy** has
a thinking man's filter...
a smoking man's taste!

VICEROY
Filter Tip
CIGARETTES
KING-SIZE

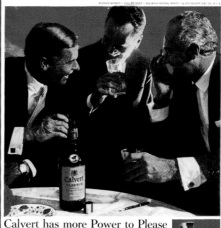

Calvert has more Power to Please

...because it's the whiskey only the Hand of Skill can blend!

Bring out the Calvert Reserve, pour a round
or two, and watch what happens. Good-
fellowship warms the room: tensions melt
away with the ice in your drinks and even an

ordinary meeting becomes a party! Calvert
Reserve has far more power to please be-
cause it combines easy-going taste with full
whiskey strength. Try it yourself, tonight!

Calvert Reserve

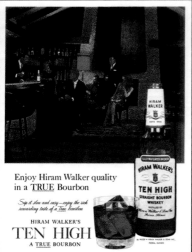

Enjoy Hiram Walker quality
in a **TRUE** Bourbon

*Sip it slow and easy—enjoy the rich
rewarding taste of a True bourbon*

HIRAM WALKER'S
TEN HIGH
A **TRUE** BOURBON

In 1571 a German doctor named
Michael Bernhard Valentini published
Polychresta Exotica (Exotic Remedies),
which stated that tobacco smoke would
cure colic, nephritis, hysteria, hernia,
and dysentery.

Got a Light?
The Spice of Vice

Arial of the Fashionable Scotch

The problem with people who have no vices is that generally you can be pretty sure they're going to have some pretty annoying virtues.
—Elizabeth Taylor

Looked at scientifically, cigarettes and booze are poisonous substances that alter our physiological processes to a point of delightful (until the next morning) discombobulation. But that's not why we love them so much. We love them because they open doors to misbehavior, let-down guards and lurid flirting. Beyond the inhibition-kill that comes with stupefaction, everyone starts to feel a little reckless when highballs and rolling papers are produced. The reason vices have always been pooh-poohed and legislated against is precisely their close association with potential pants-dropping. Of course controversy only serves to heighten the scintillation.

The relationship between vices and sex has been on display in Hollywood since time immemorial. Smoking, drinking, and falling into bed line the three-act structure like Corinthian leather. As a matter of fact, recent studies indicate that the level of smoking in films has risen since 1950, such that there are now about eleven depictions of smoking per hour in films. Although smoking is the most frequently targeted and regulated vice in the media, it has tended to slip through in the celluloid world.

Before these things were studied, everyone was atwitter when Paul Henreid lit two cigarettes and gave one to Bette Davis in *Dark Victory*, because smoking was not the only thing they were doing, and the 1939 audience got a charge out of being in on it. Drinking and smoking were to 1940s film noir what dough is to a baker, and noir exemplified the sexiest kind of glamour — rough glamour, the kind no one can resist. No matter what is being said, it always sounds dirty. *Out of the Past*, a classic of the genre, included this piquant exchange:

> "All women are wonders because they reduce all men to the obvious."
>
> "So do martinis."

Golden Age advertisers were more than willing to incorporate the hint of naughtiness wherever they could. Sometimes it was subtle, as in the Ronson lighter ad featuring a well-groomed swell book-ended by two gimlet-eyed beauties, its "three on a Ronson is good luck" message playing on the every-man's fantasy. But more often it was unapologetic (without being overt): A stunner looks back at you with intent, a bathing suit, and a Lucky Strike. A hunk towels off his date, who looks orgasmic yet still manages to unsheath a Philip Morris cigarette. "Gently does it," reads the copy. Any time the advertisers could slip a little cleavage into a scene, be it appropriate or not, you can bet your Blatz they would.

Winston was happy to put forth a nice young lady on the beach with her guy, measuring the length of a "filter-blend" Winston while the ad copy told us what she didn't have to: "It's what's up front that counts."

The Regent Cigarette boys took the high ground in one of their ads, depicting a square-jawed up-and-comer and a honey of a gal getting a light from their waiter. "Love . . . at first sight" was the message. Presumably they are falling hard for the smooth taste of the Regent tobacco blend.

Then there's Black Velvet Canadian Whiskey, who impertinently combined yuletide joy with wickedness, unveiling a blonde pin-up in a slinky black velvet cocktail dress over the tagline: "'tis the season to feel Black Velvet." Va va va voom.

Famous Opera Star tells why she changed to <u>Camels</u>

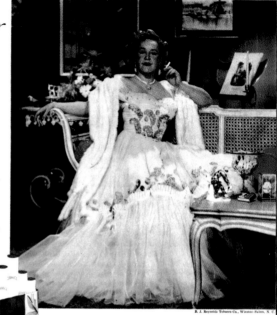

Eleanor Steber

**BRILLIANT SOPRANO OF THE
METROPOLITAN OPERA**

ELEANOR STEBER, a top ranking star of the Met for many years, is another of the many leading American personalities who changed to Camels, America's most popular cigarette!

"My first Camel made an instant hit with me. I'd never enjoyed such rich flavor in a cigarette, such smooth mildness! That's important to me. That's why I changed for good. You'll be enthusiastic about Camels, too!"

for **Mildness...**
for **Flavor**

CAMEL
CHOICE QUALITY

Camels agree with more people
THAN <u>ANY</u> OTHER CIGARETTE

Make the 30-Day Camel Mildness Test

Your own sense of good taste will tell you Camels' mildness and flavor are right for you!

IF YOU wonder if *you* should change your cigarette, consider this: Camels, year after year, are America's most popular cigarette ... first choice with millions for mildness and flavor! Surely *you* deserve the cigarette that rates tops with the most smokers! Find out yourself! Smoke only Camels for 30 days. See how Camels' costly tobaccos give unmatched mildness and rich flavor. See why Camels agree with more people than *any* other cigarette!

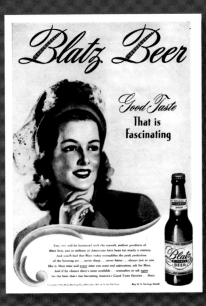

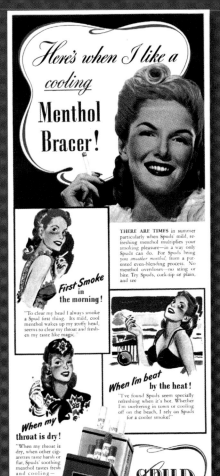

In 1955, 60 percent of men and 28 percent of women smoked. By 1990, the male smoking rate had plunged to 28 percent, compared with a drop of only five percentage points to 23 percent for women.

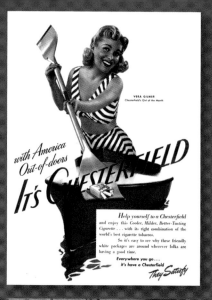

VERA GILMER
Chesterfield's Girl of the Month

with America Out-of-doors

It's CHESTERFIELD

Help yourself to a Chesterfield and enjoy this Cooler, Milder, Better-Tasting Cigarette . . . with its right combination of the world's best cigarette tobaccos.

So it's easy to see why these friendly white packages are around wherever folks are having a good time.

Everywhere you go . . .
it's have a Chesterfield
They Satisfy

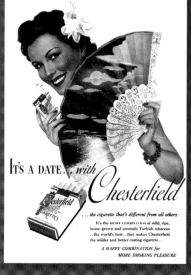

IT'S A DATE . . . *with*

Chesterfield

. . . the cigarette that's different from all others

It's the RIGHT COMBINATION of mild, ripe, home-grown and aromatic Turkish tobaccos . . the world's best . . that makes Chesterfield the milder and better-tasting cigarette . .

A HAPPY COMBINATION for
MORE SMOKING PLEASURE

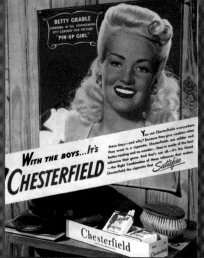

BETTY GRABLE
STARRING IN THE FORTHCOMING 20TH CENTURY-FOX PICTURE
"PIN-UP GIRL"

WITH THE BOYS . . . It's
CHESTERFIELD

You see Chesterfields everywhere these days—and why? Because they give smokers what they want in a cigarette. Chesterfields are milder and better-tasting and no wonder . . . they're made of the best tobaccos that grow. And best of all—it's the blend—the Right Combination of these tobaccos that makes Chesterfield the cigarette that *Satisfies*

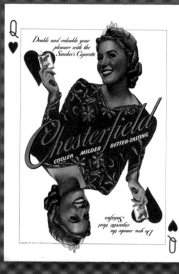

Q♥

Double and redouble your pleasure with the Smoker's Cigarette

Chesterfield
COOLER MILDER BETTER-TASTING

Do you smoke the cigarette that Satisfies

Q♠

A drinking establishment is now located in the New York City building that once housed the National Temperance Society.

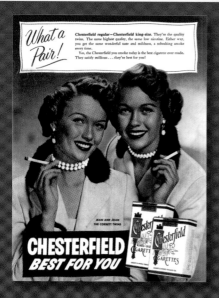

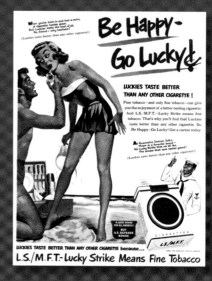

A 1997 study indicated that about a third of the global population aged 15 and older were smokers, or 1.1 billion people in all.
Of these, 800 million were in developing countries, and most of those smokers in developing countries were men (700 out of 800 million).

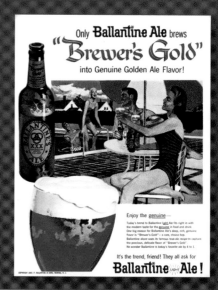

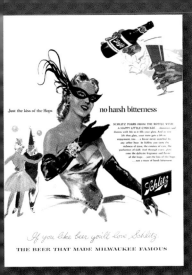
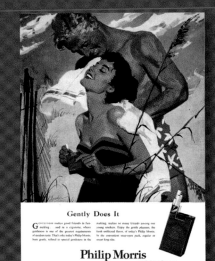
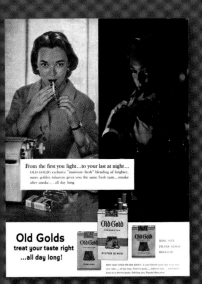
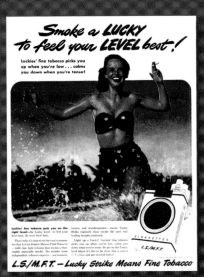

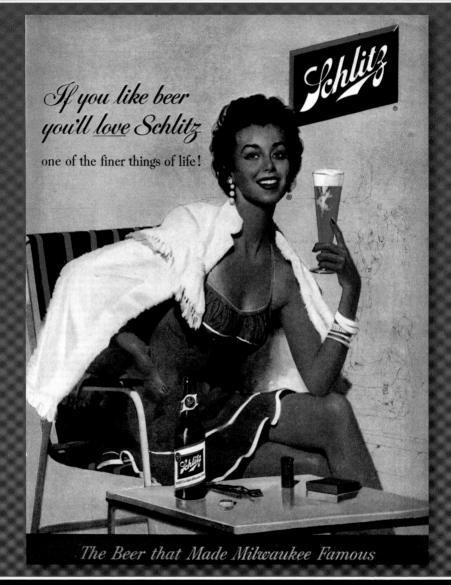

For the 1968 *You've Come a Long Way, Baby* Virginia Slims campaign, Phillip Morris conducted an opinion poll to see if the word baby was offensive before giving the go-ahead. So long and yet so far.

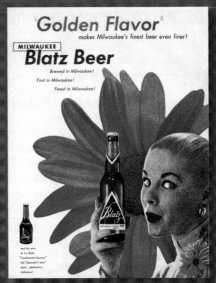

The Manhattan cocktail (whiskey and sweet vermouth) was invented by Winston Churchill's mother.

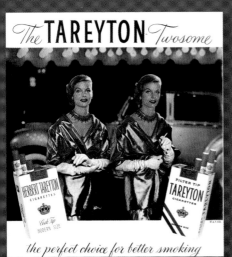

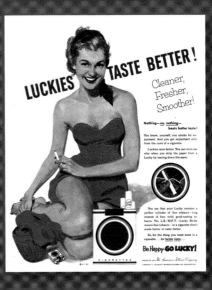

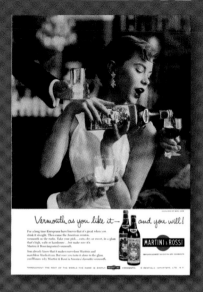

Vermouth as you like it — and you will!

MARTINI & ROSSI

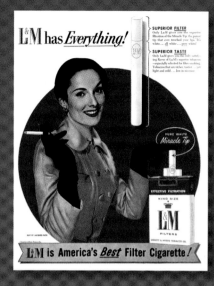

L&M has *Everything!*

SUPERIOR FILTER
Only L&M gives you the cigarette filtration of the Miracle Tip. So pure that even brushed your lips. It's white ... all white ... pure white!

SUPERIOR TASTE
Only L&M gives you the lady satisfying flavor of L&M's superior tobaccos — especially selected for filter smoking. Tobaccos that are richer, tastier ... yet light and mild ... low in nicotine.

PURE WHITE
Miracle Tip

EFFECTIVE FILTRATION

KING SIZE
L&M
FILTERS

LIGGETT & MYERS TOBACCO CO.

L&M is America's *Best* Filter Cigarette!

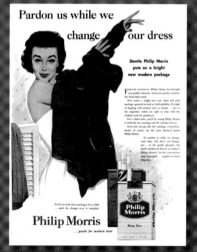

Pardon us while we change our dress

Gentle Philip Morris
puts on a bright
new modern package

Philip Morris

King Size

...gentle for modern taste

Two studies by the Massachusetts Department of Public Health and the nonprofit American Legacy Foundation document that cigarette makers have increased their advertising in magazines with large readerships by teenagers, this after agreeing in a 1998 court settlement not to target teens in their ads.
In the first 9 months of 1999, the industry spent $119.9 million on cigarette ads in magazines with a large percentage of teen readers, such as *Rolling Stone*, *Glamour*, *Motor Trend*, and *Sports Illustrated*.

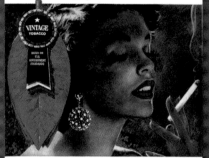
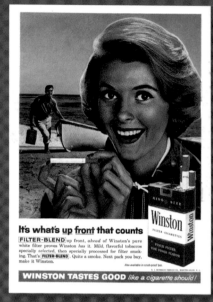
In a 1970 survey of readers of *Psychology Today*, 45 percent of
men and 68 percent of women stated that alcohol enhanced sexual
enjoyment. 13 percent of men and 11 percent of women stated that
alcohol has no effect, and 42 percent of men and 21 percent of women
reported decreased enjoyment.

Smokers metabolize caffeine at an increased rate. When a smoker quits, the amount of caffeine ingested in a cup of coffee is higher, and the result can be unexpected jitteriness.

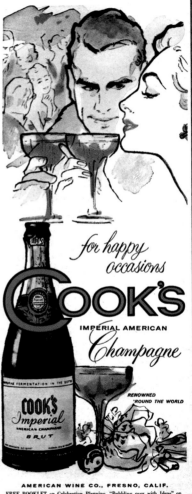

for happy occasions

COOK'S
IMPERIAL AMERICAN
Champagne

RENOWNED
'ROUND THE WORLD

COOK'S
Imperial
AMERICAN CHAMPAGNE
BRUT

AMERICAN WINE CO., FRESNO, CALIF.

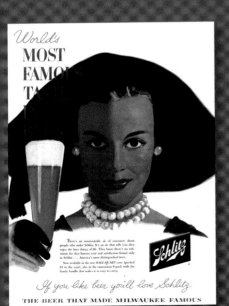

World's
MOST
FAMOUS
TAS

Schlitz

If you like beer you'll love Schlitz

THE BEER THAT MADE MILWAUKEE FAMOUS

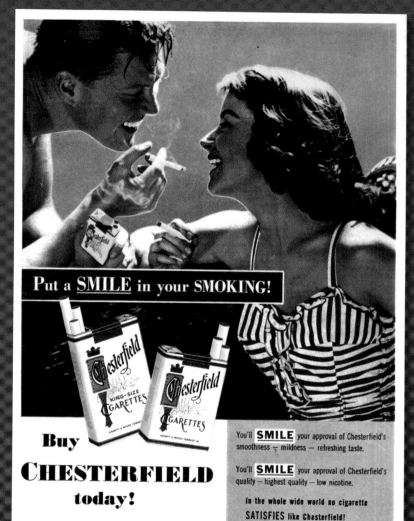

Put a **SMILE** in your SMOKING!

Buy **CHESTERFIELD** today!

You'll **SMILE** your approval of Chesterfield's smoothness — mildness — refreshing taste.

You'll **SMILE** your approval of Chesterfield's quality — highest quality — low nicotine.

In the whole wide world no cigarette SATISFIES like Chesterfield!

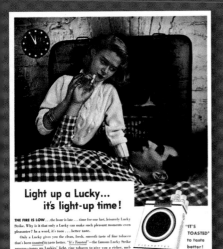

Light up a Lucky...
it's light-up time!

THE FIRE IS LOW...the hour is late...time for one last, leisurely Lucky Strike. Why is it that only a Lucky can make such pleasant moments even pleasanter? In a word, it's taste...better taste.

Only a Lucky gives you the clean, fresh, smooth taste of fine tobacco that's been toasted to taste better. "It's Toasted"—the famous Lucky Strike process—tones up Luckies' light, ripe tobacco to give you a richer, mellower flavor, a truly satisfying taste. Next time you buy a pack, try a pack of Luckies.

"IT'S TOASTED" to taste better!

LUCKIES TASTE BETTER – *Cleaner, Fresher, Smoother*

A patient who quits smoking at the birth of a child will have saved enough money to pay for the child's college education by the time that bill comes due.

Desi Arnaz's grandfather was one of the founders of the largest rum distillery in the world.

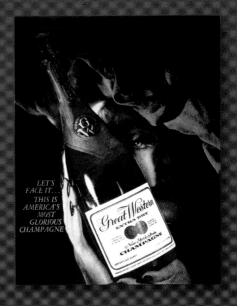

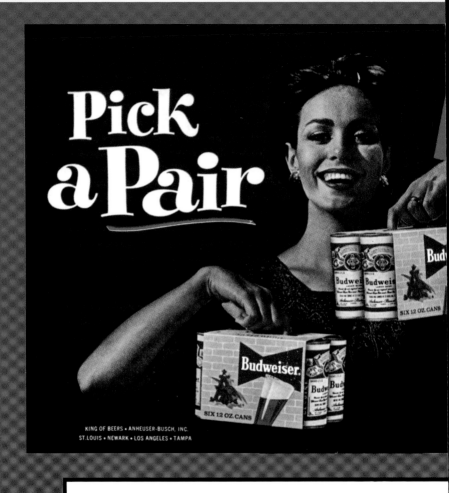

Pick a Pair

Budweiser.
SIX 12 OZ. CANS

KING OF BEERS • ANHEUSER-BUSCH, INC.
ST.LOUIS • NEWARK • LOS ANGELES • TAMPA

Smokers have 50 percent more car accidents than nonsmokers. Th[e]
and smoking while driving is a significant factor.

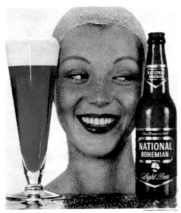

Wet, Cold and Delicious...just the way you want your beer

National Bohemian Beer

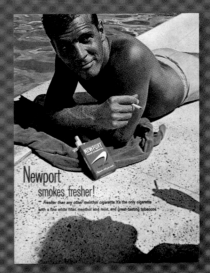

Newport
smokes fresher!
*Fresher than any other menthol cigarette. It's the only cigarette
with a fine white filter, menthol and mint, and great-tasting tobacco.*

ion of lighting up

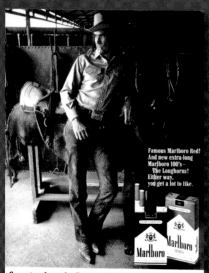

Famous Marlboro Red! And new extra-long Marlboro 100's – The Longhorns! Either way, you get a lot to like.

Come to where the flavor is. Come to Marlboro Country.

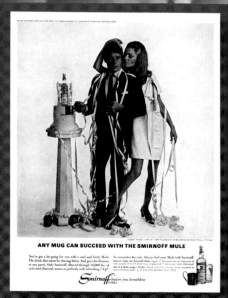

ANY MUG CAN SUCCEED WITH THE SMIRNOFF MULE

Smirnoff leaves you breathless

If a young Tiriki man offers beer to a woman and she spits some of it into his mouth, they are engaged to be married.

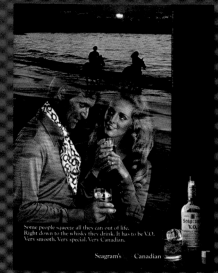

Some people squeeze all they can out of life. Right down to the whisky they drink. It has to be V.O. Very smooth. Very special. Very Canadian.

Seagram's Canadian

On average, smokers weigh about seven pounds less than nonsmokers.

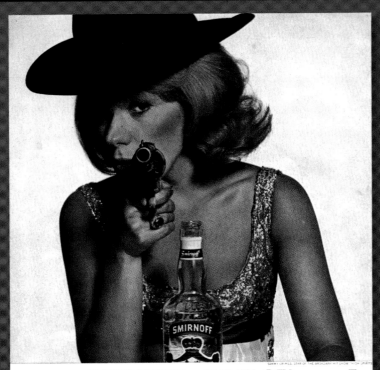

SMIRNOFF...OR ELSE!

Make sure they get the message. *It's Smirnoff you want.* For dryer Martinis. Delicious Screwdrivers. The smoothest drink on-the-rocks. It's the crystal-clear liquor that's filtered through 14,000 pounds of activated charcoal. It's the flawlessly smooth vodka that mixes perfectly with anything that pours. No wonder you want Smirnoff — and *only* Smirnoff. At a bar, *demand* it.

Always ask for *Smirnoff* It leaves you breathless® VODKA

You get a lot to
with a Mar
–the filter cigarette with th
unfiltered taste

The secret of Marlboro's unfiltered taste, of course, is the famous
Marlboro Recipe from Richmond, Virginia—and just the right
filter to go with it. If a regular Marlboro smoker tells you this
cigarette has been still further improved lately, he's right.
Try today's Marlboro and judge for yourself.

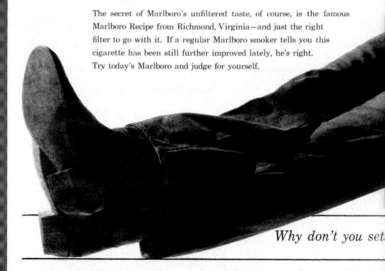

Why don't you set

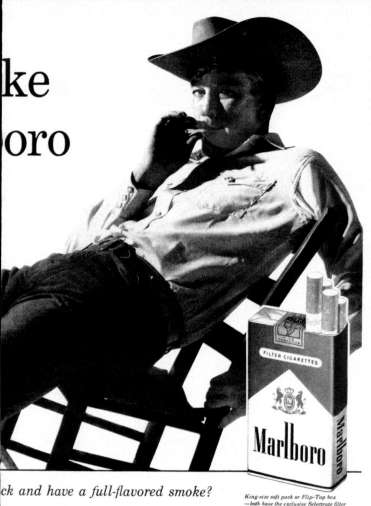

ke
oro

ck and have a full-flavored smoke?

FILTER CIGARETTES

Marlboro

King-size soft pack or Flip-Top box
—both have the exclusive Selectrate filter

To the Good Life
Recreational Vice

Many prominent athletes smoke Luckies all day long with no harmful effects to wind or physician condition.
—Lucky Strikes ad, 1929

Baseball cards, which have become a gargantuan industry and, as a hobby, the wellspring of countless nerd jokes, were created by nineteenth-century tobacco companies looking for new ways to advertise. The 1909 Honus Wagner T-206, often referred to as the Holy Grail of sports collectibles, went for $1.7 million in 2000. The reason cited for its scarcity, and therefore its colossal price tag, is that Wagner disapproved of tobacco products (and their influence on the youth of the day) and ordered the card pulled from production. This explanation hasn't held up completely, since Wagner lent his image to several other tobacco promotions and posed for several pictures with a juicy chaw of tobacco between tooth and gum. Some, including talking head Keith Olbermann, speculate that perhaps ol' Honus liked tobacco as much as the next guy (it was pretty much *de rigeur* at the time), but felt he wasn't getting paid enough by the American Tobacco Company.

Sports stars in the 1940s and 1950s appeared regularly and unapologetically in cigarette and booze ads, happily pocketing the extra cash and, no doubt, free product. Joe DiMaggio, Bob Cousy, Frank Gifford, and Arnold Palmer are some examples of athletes at the pinnacle of their respective sports who appeared in ads blissfully enjoying a butt. They, like most of the country, didn't think much about the implications. They smoked between games, why not get paid to say so? In 1945, Dodgers manager Leo Durocher prescribed a couple of fingers of brandy for Tom Seats, a pitcher with a case of pre-outing jitters. Jim Bouton's *Ball Four* lays out, in great detail, Major League Baseball's reliance on beer and greenies. Mickey Mantle is said to have partied particularly hard the night before a game in which he didn't think he'd have to play. Lo and behold the Mick, hungover to the point of near-blindness, was asked to pinch hit with the game on the line.

He homered. This outcome didn't do much to curb Mantle's benders, and his battles with alcoholism are well documented.

Booze and cigarette companies loved to paint a sporting scene for their prospective buyers. The association was healthy, all-American, and high-energy. Camel trotted out a series of sportsmen engaging in hearty pursuits in support of its "every inch a real smoke" campaign (the bedroom association was gravy). The fisherman stood with his fishing tackle and a Camel; the deep-sea diver had one last puff before getting back to the life of scuba. Kool showed some schuss-ers sneaking a smoke break on the chair lift, enjoying a "Snow Fresh Filter Kool" between black diamonds. The Schenley whiskey company went the alpine route as well, though they added a very sensible "when day is done" to their exhortation. Bowling, tennis, hockey, fox-hunting . . . no sport was overlooked in the pursuit of those who liked to sin legally. Glenmore Distilleries may have miscalculated a bit (or maybe not) with its scene of successful gents in the locker room after a round of golf. Seems like the guy in the towel is looking just a little *too* intently at the silver fox with the monster highball of Kentucky Tavern.

In 1964 the tobacco industry drew up a "Cigarette Advertising Code," whose focus was avoiding the perception that the youth of America were being targeted. But those in charge of enforcing the code were flummoxed by the slippery nature of advertising messages (not to mention advertising executives). Cigarette advertisers were permitted to show sportsmen smoking while relaxing after a session of tennis or waterskiing, but never during the act, unless it was sailing or fishing, in which cases during was okay. Though the use of name athletes in ads was prohibited, the code didn't mention smokeless tobacco, so Skoal and Copenhagen kept using sports heroes.

Alcohol ads have been far less regulated. The "Tastes Great, Less Filling" Miller Lite campaign that lasted from the early 1970s to the late 1980s was one of the most successful campaigns of all time. (Miller sales shot from almost seven million barrels in 1973 to more than thirty-one million in 1978.) Athletes basically acted like themselves in odd barroom situations and people ate it up. When Bubba Smith, a fearsome presence and Lite Beer ad regular, decided to stop doing the spots because he felt they promoted underage drinking, Miller promptly replaced him with L. C. Greenwood, who loved the easy-opening cans (he tore them open with his bare hands).

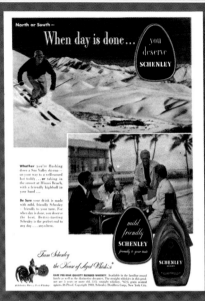

Pot Luck, 1943

Jim Leyland, manager of the Pirates, Marlins, and Rockies from 1986 to 1999, was an inveterate smoker and was caught from time to time by TV cameras sneaking a smoke in the dugout.

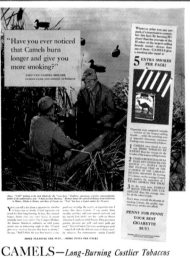

Among the Lepcha people of Tibet, teachers are paid in alcohol.

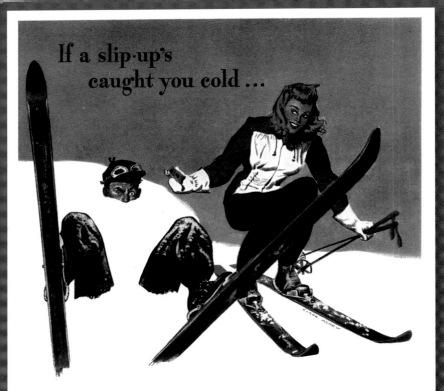

If a slip-up's caught you cold ...

Why be Irritated ?
Light an Old Gold

Yes, Old Golds store a treasure of *extra* little gifts for you! There's
the kindliness of Apple "Honey"* to keep 'em moistly fresh . . .
the generous blend of world-famous tobaccos for sheer pleasure
. . . the bonus-touch of rare, imported Latakia tobacco for extra
flavor. Here's another refinement, too. Only *virgin pure
flax* is used in making Old Golds' snowy cigarette paper.
Old Golds are *your* kind of cigarette—why don't you try them?

LISTEN TO
FRANK SINATRA
Wednesday Evenings CBS
and
MEET ME AT PARKY'S
Sunday Evenings NBC

Made from the juice of fresh apples, a special moisture-guarding agent we call Apple "Honey" helps keep Old Golds free from cigarette dryness.

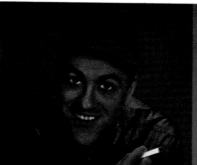
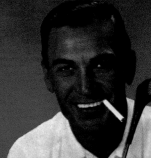
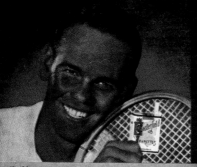

"...s the one I'm really glad to put my name ...my cigarette." *Joe DiMaggio*

STAR OF THE NEW YORK YANKEES

"...rfields have what I want in a smoke, real ...s and better taste." *Frankie Albert*

STAR BACK OF THE SAN FRANCISCO 49'ERS

The TOP MEN in America's Sports

tell you WHY every smoker should smoke Chesterfield

← READ WHAT THEY SAY

CHESTERFIELD

— *much* MILDER....*They Satisfy*

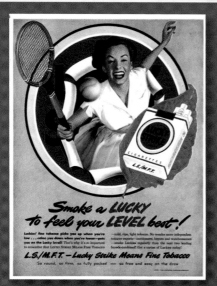

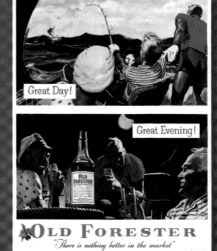

Clove cigarettes are imported from Southeast Asia, primarily Indonesia, and are composed of approximately one-third shredded cloves and two-thirds a strain of tobacco that delivers about twice as much tar and nicotine as U.S. tobacco. They also contain substantial amounts of eugenol, an anesthetic agent. Nearly 170 million were consumed in the United States at the height of their popularity in 1984.

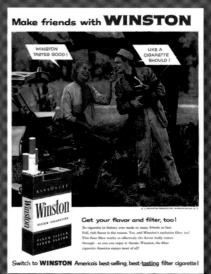

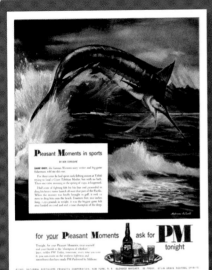

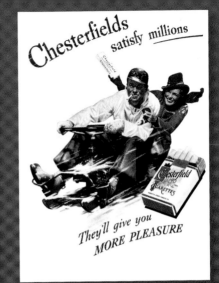

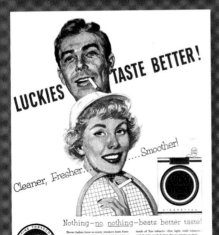

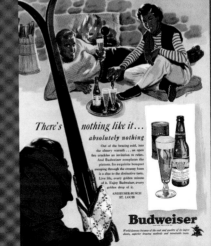

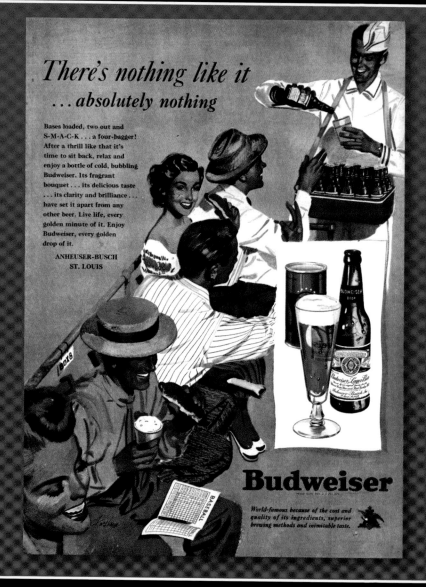

There's nothing like it
...absolutely nothing

Bases loaded, two out and
S-M-A-C-K . . . a four-bagger!
After a thrill like that it's
time to sit back, relax and
enjoy a bottle of cold, bubbling
Budweiser. Its fragrant
bouquet . . . its delicious taste
. . . its clarity and brilliance . . .
have set it apart from any
other beer. Live life, every
golden minute of it. Enjoy
Budweiser, every golden
drop of it.

ANHEUSER-BUSCH
ST. LOUIS

Budweiser

*World-famous because of the cost and
quality of its ingredients, superior
brewing methods and inimitable taste.*

In the 1950s, P. Lorillard debuted a "Micronite" filter in Kent cigarettes to replace the previous filter, whose primary agent was crocidolite asbestos.

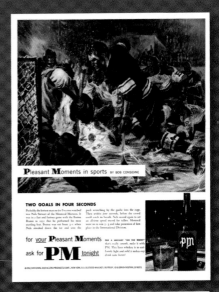

Pleasant Moments in sports BY BOB CONSIDINE

TWO GOALS IN FOUR SECONDS

for your Pleasant Moments ask for **PM** tonight

DISCRIMINATING PEOPLE PREFER HERBERT TAREYTON

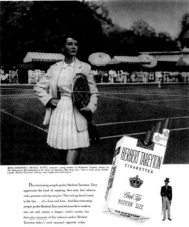

THERE'S SOMETHING ABOUT THEM YOU'LL LIKE

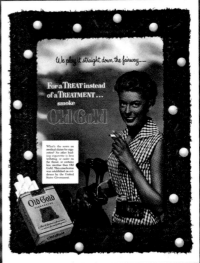

We play it straight down the fairway—

For a TREAT instead of a TREATMENT... smoke Old Gold

The Chagga people of Tanganyika believe that a liar will be poisoned if he or she consumes beer mixed with the blood of a recently sacrificed goat.

The national anthem of the United States, the "Star-Spangled Banner," was written to the tune of a drinking song.

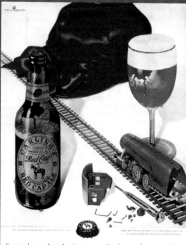

Somewhere close by is a man who knows how to enjoy a hobby and a wonderful glass of ale, too.

CARLING'S *Red Cap* **ALE**

Brilliant conclusion to a World Series battle

Seagram's

IMPORTED CANADIAN

VO

known by the company it keeps

In that companionable moment after the big game becomes history, V.O. always puts the celebration. In fact, whatever in the world sportsmen gather, this fine Canadian whisky, a faultless modern triumph of an age-old art, proves it's an international favorite of our time.

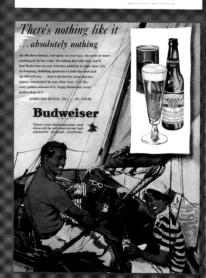

There's nothing like it ...absolutely nothing

An off-shore breeze, cool spray on your face, the swirl of water swishing by in her wake. On sailing days like this, you'll find Budweiser an ever welcome addition to your crew. Lift its foaming, bubbling goodness to your lips and each sip will tell you . . . here's distinctive taste and eye appeal unmatched by any other beer. Live life, every golden minute of it. Enjoy Budweiser, every golden drop of it.

ANHEUSER-BUSCH, INC. • ST. LOUIS

Budweiser

There's more Budweiser now—and there will be still more as our vast expansion program continues.

132

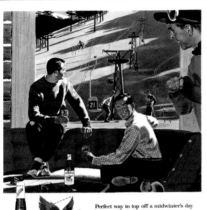

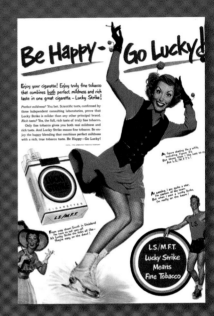

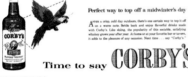

Perfect way to top off a midwinter's day

Time to say **CORBY'S**

Be Happy—Go Lucky!

According to the World Health Organization, tobacco companies produce cigarettes at the rate of 5.5 trillion a year, or nearly 1,000 cigarettes for every man, woman, and child on the planet.

In 1947 *Smoke! Smoke! Smoke! (That Cigarette)*, written by Merle Travis for Tex Williams, was a hit.

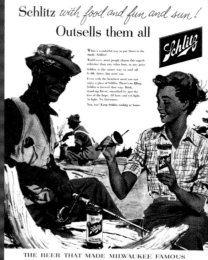

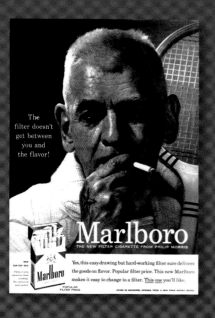

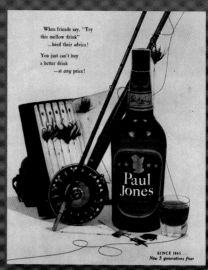

The shallow champagne glass originated with Marie Antoinette. It was first formed from wax molds made of her breasts.

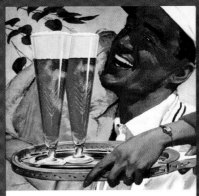

The goodness of Malt
helps beer do more than quench your thirst

HEALTHFUL VALUES join the Fun-Flavored refreshment of beer brewed with Barley Malt. You satisfy your thirst — and more — because Malt contributes dextrins and maltose that aid digestion. B-complex vitamins and metal minerals, too. These healthful factors are good reasons why you're wise to enjoy beer and every other food product that contains Malt.

For facts about this healthful product — exciting recipes, too — get your free copy of the Homemaker's Guide to Barley Malt. Write Dept. 1, Barley & Malt Institute, 221 North LaSalle, Chicago 1, Illinois.

Barley and Malt
INSTITUTE

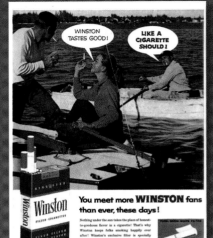

WINSTON TASTES GOOD!

LIKE A CIGARETTE SHOULD!

You meet more WINSTON fans than ever, these days!

Nothing under the sun takes the place of honest-to-goodness flavor in a cigarette! That's why Winston keeps folks smoking happily ever after! Winston's exclusive filter is specially made to let you get rich, full-flavor enjoyment. Try a pack. You'll see why Winston is far and every America's best-selling filter cigarette!

Smoke WINSTON America's best-selling, best-tasting filter cigarette!

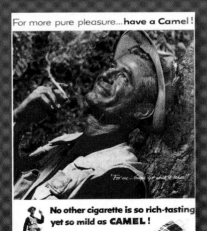

For more pure pleasure... **have a Camel!**

"For me — there's got what it takes"

No other cigarette is so rich-tasting yet so mild as CAMEL!

● THIS you'll notice about Camel smokers: they get more pure pleasure from smoking! Year after year, Camels lead all other brands because no other cigarette has ever matched Camel's richer blend. No other cigarette is so rich-tasting, yet so mild as Camel. Make your own 30-day Camel Mildness Test. Find out for yourself how wonderfully Camels agree with you!

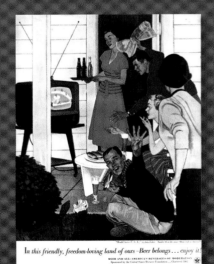

In this friendly, freedom-loving land of ours - Beer belongs ... enjoy it!

BEER AND ALE—AMERICA'S BEVERAGES OF MODERATION
Sponsored by the United States Brewers Foundation ... Chartered 1862

135

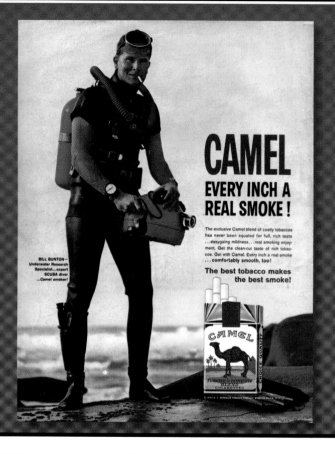

CAMEL
EVERY INCH A REAL SMOKE !

The exclusive Camel blend of costly tobaccos has never been equaled for full, rich taste ...easygoing mildness...real smoking enjoyment. Get the clean-cut taste of rich tobaccos. Get with Camel. Every inch a real smoke ...comfortably smooth, too!

The best tobacco makes the best smoke!

BILL GUNTON—
Underwater Research
Specialist... expert
SCUBA diver
...Camel smoker!

The 1935 Camel campaign used baseball legend Lou Gehrig and tennis great Bill Tilden as spokesmen. Gehrig's ad went like this: "So mild, you can smoke all you want." Tilden's: "Playing competitive tennis day after day, I've got to keep in top physical condition. I smoke Camels, the mild cigarette." The smoker struggling with the concept of balancing smoking and an active lifestyle very much appreciated this bit of permission.

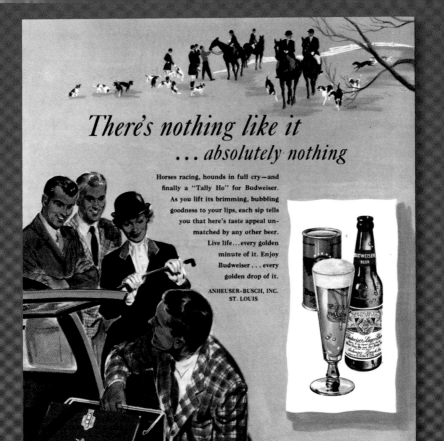

There's nothing like it
...absolutely nothing

Horses racing, hounds in full cry—and finally a "Tally Ho" for Budweiser. As you lift its brimming, bubbling goodness to your lips, each sip tells you that here's taste appeal unmatched by any other beer. Live life...every golden minute of it. Enjoy Budweiser...every golden drop of it.

ANHEUSER-BUSCH, INC.
ST. LOUIS

Budweiser
TRADE MARK REG. U. S. PAT. OFF.

There's more Budweiser now—and there will be still more as our vast expansion program continues.

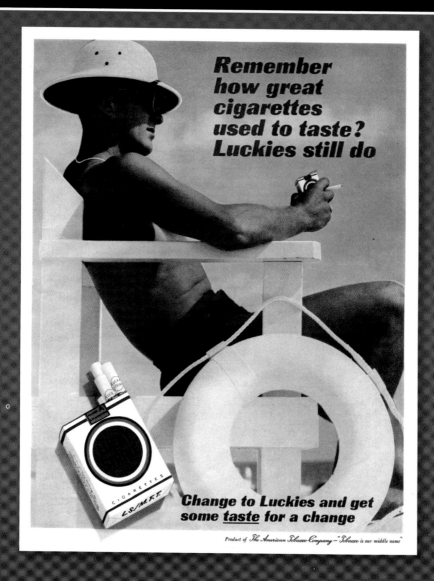

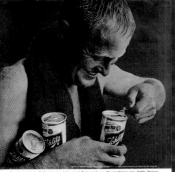

Be glad you're thirsty. Schlitz drinks down light and cool. Tastes great, even after your thirst is gone. Schlitz, The beer that made Milwaukee famous simply because it tastes so good. Now in the Pop Top—the can with the built-in opener!

real gusto
in a great light beer

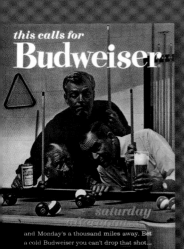

this calls for
Budweiser

saturday afternoon

and Monday's a thousand miles away. Bet a cold Budweiser you can't drop that shot...

Where there's life...there's Bud.

Thirteenth century doctors referred to alcohol as *aqua vitae*, or the water of life.

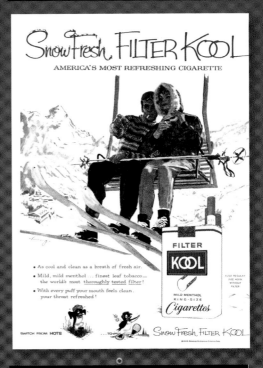

As a part of the Marshall Plan in 1948 and 1949, 93,000 tons of free tobacco were shipped to Germany.

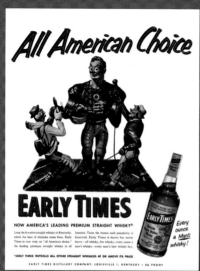

All American Choice

EARLY TIMES

NOW AMERICA'S LEADING PREMIUM STRAIGHT WHISKY®

Long the favorite straight whisky in Kentucky, where the best of whiskies come from, Early Times is now truly an "all American choice," the leading premium straight whisky in all America. Taste the reason such popularity is deserved. Early Times is hearty but never heavy—all whisky, fine whisky, every ounce a man's whisky—every man's best whisky buy.

Every ounce a Man's whisky!

*EARLY TIMES OUTSELLS ALL OTHER STRAIGHT WHISKIES AT OR ABOVE ITS PRICE

EARLY TIMES DISTILLERY COMPANY, LOUISVILLE 1, KENTUCKY · 86 PROOF

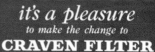
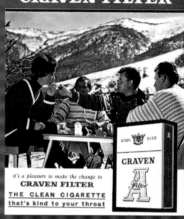
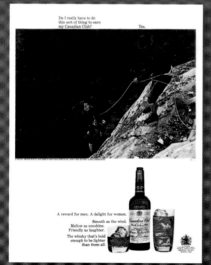

Do I really have to do
this sort of thing to earn
my Canadian Club? Yes.

A reward for men. A delight for women.
Smooth as the wind.
Mellow as sunshine.
Friendly as laughter.
The whisky that's bold
enough to be lighter
than them all.

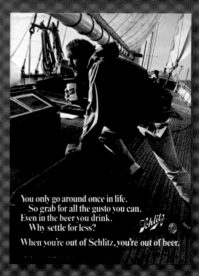

You only go around once in life.
So grab for all the gusto you can.
Even in the beer you drink.
Why settle for less?

Schlitz

When you're out of Schlitz, you're out of beer.

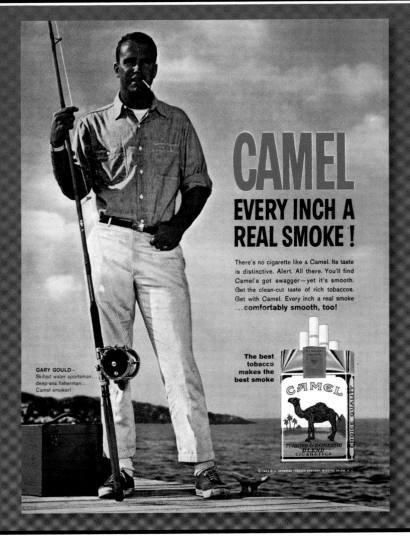

CAMEL
EVERY INCH A REAL SMOKE!

There's no cigarette like a Camel. Its taste is distinctive. Alert. All there. You'll find Camel's got swagger — yet it's smooth. Get the clean-cut taste of rich tobaccos. Get with Camel. Every inch a real smoke ...comfortably smooth, too!

GARY GOULD — Skilled water sportsman... deep-sea fisherman... Camel smoker!

The best tobacco makes the best smoke

Camel
TURKISH & DOMESTIC BLEND CIGARETTES

© 1963 R. J. REYNOLDS TOBACCO COMPANY, WINSTON-SALEM, N. C.

Beer was not sold in bottles until 1850; it was not sold in cans until 1935.

A Happy Blending
Companion Vice

Persons who drink no alcohol at all are less well adjusted than persons who drink moderate amounts.
—Cook, Young, Taylor & Bedford; *Personality and Individual Differences* (1998), University of Wales

The poet Robert Lowell called alcohol "that sociable drop . . . that makes us all one species in warmth, weakness, and talkativeness." However you come down on the question of whether vices are good or bad, we've come to depend on them, and there are those who will go to great lengths to defend them as not only necessary, but vital. Maybe they don't take it to the level of the ancient Egyptians, who gave their children names like How Drunk Is Cheops and How Intoxicated Is Hathor (although I have met a Gin), but vices are bound up, inextricably, in the fabric of society.

The world is an oppressive and menacing place, so it certainly helps to have a quick swig or sneak a puff before you address the press corps or approach the woman you've seen around but who appears to be oblivious to your existence. There are magical questions, like "Got a light?" "Can I buy you a drink?" — even "Mind if I smoke?" — that can always be depended upon when you find yourself in a spot. They are stock, but somehow not hackneyed. It's okay that both parties know what's really being said, which is, "Please help me, I'm alone at this party and I don't like the way it looks." If the approachee doesn't feel like throwing out a lifeline, well, you were just asking for a light and you move on. If you make it overly clear via excessive winking and eyebrow-raising what your real objective is, that's not the question's fault.

On the very simple level of oral and manual satisfaction, vices are tried and true personal assistants. Whether hands-free awkwardness is self-created or not, we just feel less at sea when holding something. And a cigarette or a drink is far more justifiable than, say, a set of worry beads. Freud had lots to say about oral satisfaction and what it all meant but (apocryphally) defended his own smoking by saying "Sometimes a cigar is just a cigar."

In Francis Sill Wickware's 1946 *Life* magazine essay on the "30,000-year-old problem of drinking," she quotes a Dr. Donald Horton (from his symposium on Alcohol, Science and Society) as saying that alcohol "has been successful in the face of very severe opposition . . . We have to conclude from this, then, that some important human value is involved here that makes alcohol hard to abolish." Clearly Don knew his way around a party.

So, the ad execs figured, we'll just feature jovial people with a few brews and a carton of Merit Ultra-Lights and call it a day. Thus was born the most enduring kind of vice ad: the livin'-it-up ad. Attractive folks frolicking, giggling, bantering amongst themselves at a beach or a cocktail party or an office function — who wouldn't want an all-access pass to that?

Country Club Malt Liquor filled one ad with young, urbane types gathered around the barbecue, the host in his chef hat offering wieners to his good friends (though they are all ignoring him). "New . . . Party Brew!" says the ad. Old Forester went for the stuffy set with its portrait of successful banker-types gathered at the club, swapping stories about margins and foreclosures. Pipes are lit and drinks are forever full. To these titans, this is a day at the beach.

Schlitz made a move toward a stick-in-their-mind concept with a two-page "Life is Wonderful in Schlitzerland" ("or how Schlitz makes good neighbors") approach. An upscale cartoon rendering presented suburbia times ten: tree-lined, harmonious, everyone outside and smiling. And Schlitz was fueling it all. Get drunk with your neighbors and be happy! Wife-swap! Do whatever! In order to stay true to the Schlitzerland concept, a man in lederhosen was thrown in. He deserved some fun, too.

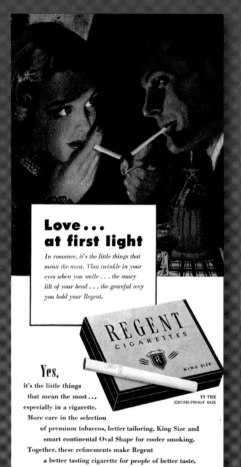

Love... at first light

In romance, it's the little things that mean the most. That twinkle in your eyes when you smile . . . the saucy lilt of your head . . . the graceful way you hold your Regent.

REGENT CIGARETTES

KING SIZE

IN THE
CRUSH-PROOF BOX

Yes,

it's the little things
that mean the most . . .
especially in a cigarette.
More care in the selection

of premium tobaccos, better tailoring, King Size and
smart continental Oval Shape for cooler smoking.
Together, these refinements make Regent
a better tasting cigarette for people of better taste.
You'll love Regent first, last and always.

REGENT *The Luxury Smoke at Popular Price*

the flowers that bloom in the Spring...

bring Apple "Honey" to Old Golds

Old Gold CIGARETTES

In the six years following the introduction of Virginia Slims in 1968, the number of teenage girls who smoked more than doubled, while smoking among adult women remained relatively constant.

Precious Cargo!

Whether you're toting a few cold bottles to a favorite picnic spot—or having SCHLITZ brought on a silver tray at the club —the beer that made Milwaukee famous is truly "precious cargo." For its smoothness and delicacy have no equal—and its famous flavor is prized by every lover of fine beer.

JUST

THE *kiss*

OF THE HOPS

...no bitterness

Copr. 1933, Jos. Schlitz Brewing Co., Milwaukee, Wis.

THE BEER THAT MADE MILWAUKEE FAMOUS

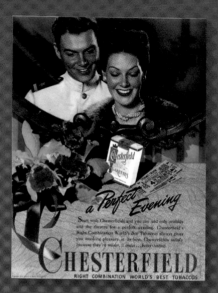

It has often been rumored that the soldiers at Custer's Last Stand at Little Big Horn were drunk the night before and the day of the battle. Custer's second in command, Marcus Reno, who was forced to retreat and survived the battle while Custer and his men were slaughtered, was known as a heavy drinker.

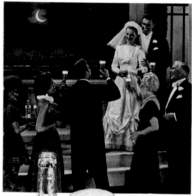
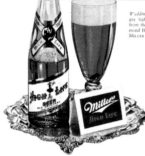

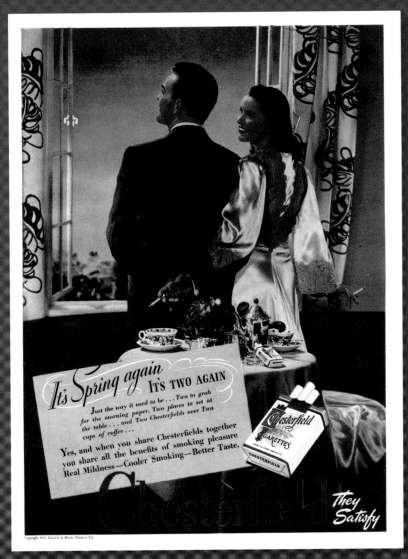

It's *Spring again*

IT'S TWO AGAIN

Just the way it used to be . . . Two to grab for the morning paper, Two places to set at the table . . . and Two Chesterfields over Two cups of coffee . . .

Yes, and when you share Chesterfields together you share all the benefits of smoking pleasure Real Mildness—Cooler Smoking—Better Taste.

Chesterfield

They Satisfy

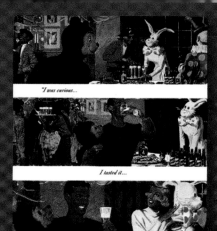

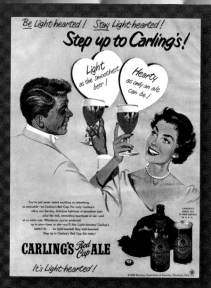

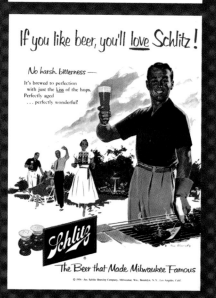

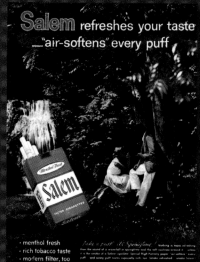

Masters and Johnson observed that secondary impotence in males in their late 40s and 50s "has a higher incidence of direct association with excessive alcohol consumption than with any other factor."

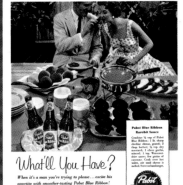

For Your Sociable Snacks...

What'll You Have?

When it's a man you're trying to please...excite his appetite with smoother-tasting Pabst Blue Ribbon!

You'll win him with your "Cheeseburger Rarebit" if you co-star it with Pabst Blue Ribbon — the smoother...more refreshing beer that makes all good foods taste better.

P.S. For the thirsty days ahead, keep a case of smooth, sociable, satisfying Pabst Blue Ribbon cooled and ready to quench thirst, at mealtime, party-time or bedtime.

Pabst Blue Ribbon

Finest Beer Served... Anywhere!

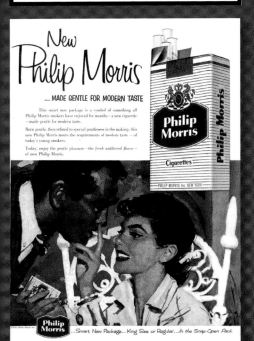

New

Philip Morris

—MADE GENTLE FOR MODERN TASTE—

This smart new package is a symbol of something all Philip Morris smokers have enjoyed for months—a new cigarette —made gentle for modern taste.

Born gentle, then refined to special gentleness in the making, this new Philip Morris meets the requirements of modern taste—of today's young smokers.

Today, enjoy the gentle pleasure—the *fresh unfiltered flavor*—of new Philip Morris.

Philip Morris

...Smart New Package... King Size or Regular...In the Snap-Open Pack.

In 1950, TV's *Your Hit Parade* was sponsored by Lucky Strike. That same year, Lucky Strike's "Be Happy, Go Lucky" won Commercial of the Year in *TV Guide.*

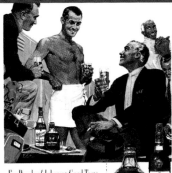

For People of Inherent Good Taste

The fellowship of good taste admits only the finest to its ranks. And so when whiskies are served in such company, the choice lies exclusively between King's Ransom and Kentucky Tavern. King's Ransom for those who prefer the finest in Scotch. Kentucky Tavern for the true Bourbon taste. Each is a proud offering of the House of Glenmore—the Scotch a hearty Highland whisky, rich in rugged vigor; the Bourbon a choice, rare smack of traditional Kentucky character. Try them both. Your own good taste will tell you that the little extra they cost is small measure of the rare enjoyment they provide.

GLENMORE DISTILLERIES Company
"Where Perfection of Product is Tradition"
LOUISVILLE, KENTUCKY

KING'S RANSOM...
Famous "Round the World" Blended Scotch Whisky • 86 Proof • Imported solely by Glenmore Distilleries

KENTUCKY TAVERN...
Kentucky Straight Sour Mash Bourbon, Bottled-in-Bond, 100 Proof

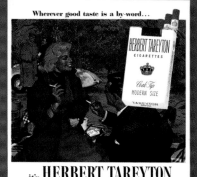

Wherever good taste is a by-word...

it's **HERBERT TAREYTON**

...with the genuine cork tip for better smoking

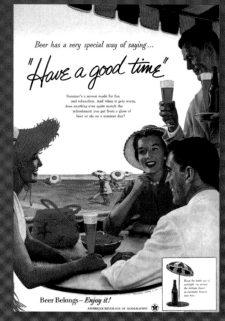

Beer has a very special way of saying...

"*Have a good time*"

Summer's season made for fun and relaxation. And when it gets warm, does anything ever quite match the refreshment you get from a glass of beer or ale on a summer day?

Beer Belongs—*Enjoy it!*

AMERICA'S BEVERAGE OF MODERATION

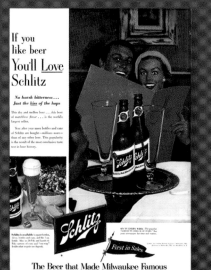

If you like beer You'll Love Schlitz

No harsh bitterness... Just the kiss of the hops

First in Sales

The Beer that Made Milwaukee Famous

Marlboros were introduced as a woman's brand in 1924, based on the slogan "Mild as May." By 1955, the focus had changed to the rugged American male — the Marlboro Man. The flip-top box was introduced in 1955 as a part of the no-nonsense, geometrical box design. Eight months after the campaign opened, sales increased 5,000 percent. Marlboros soon became the nation's top-selling brand.

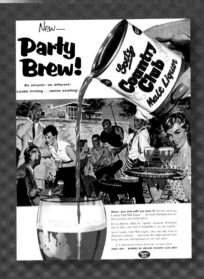

In 1934, Americans drank about 63 percent of their absolute alcohol in beer, 30 percent in spirits, and 7 percent in wine. By the mid-1960s, beer had slipped to some 47 percent, while spirits and wine had climbed respectively to 43 and 11 percent.

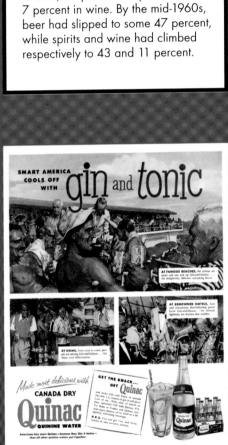

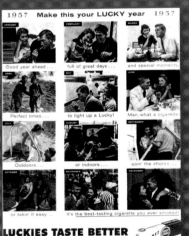

In the 1600s, thermometers
were filled with brandy
instead of mercury.

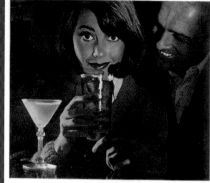

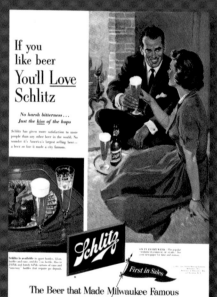

If you
like beer
You'll Love
Schlitz

*No harsh bitterness...
Just the <u>kiss</u> of the hops*

Schlitz has given more satisfaction to more
people than any other beer in the world. No
wonder it's America's largest selling beer...
a beer so fine it made a city famous.

Schlitz is available in quart bottles, 12-oz.
bottles and cans, and the 7-oz. bottle. Also in
24-Pak and handy 6-Pak cartons of cans and
"no-return" bottles that require no deposit.

*ON TV EVERY WEEK—The popular
"SCHLITZ PLAYHOUSE of STARS." See
your newspaper for time and station.*

Schlitz

First in Sales

The Beer that Made Milwaukee Famous

If you think Bacardi is enjoyable only in cocktails
you've been missing half the fun—
BACARDI IS FOR HIGHBALLS, TOO!

Sure, Bacardi Rum makes great cocktails. That's why most people make their Dai-
quiris with Bacardi. Bacardi is light-bodied, very smooth—and dry." Doesn't it stand
to reason then that Bacardi, the world's great rum, makes a light, dry, smooth high-
ball, too? You bet it does.!

If you have some Bacardi handy, discover one of the Great Dry Drinks tonight—a
highball with your favorite mixer, or the new Bacardi Devil. It'll open up a whole new
world! (Incidentally, if you don't have any Bacardi, you've been missing all the fun!)

BUY DRY **BACARDI** ENJOYABLE ALWAYS AND ALL WAYS

Nineteenth century doctors
believed strong morals led to a
healthy body, while sinful living
made you sick.

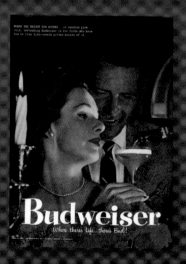

WHERE THE BRIGHT SUN SHINES ... or candles glow ...
mild, refreshing Budweiser is for folks who know
how to live life—every golden minute of it.

Budweiser

Where there's life...there's Bud!

Known Everywhere as America's Guest Whisky

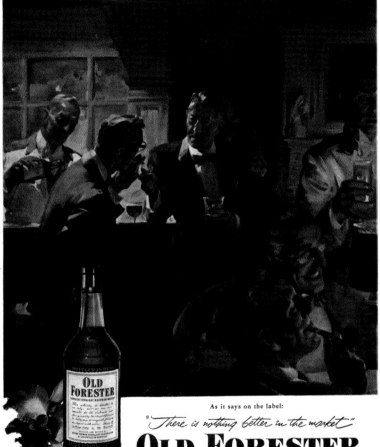

As it says on the label:

"There is nothing better in the market"

OLD FORESTER

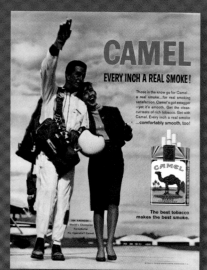

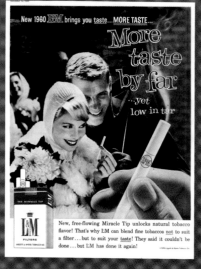

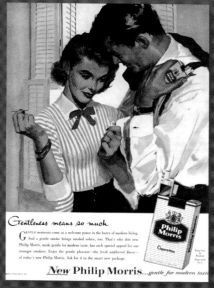

Schlitzerland, U.S.A.

OR HOW SCHLITZING MAKES GOOD NEIGHBORS

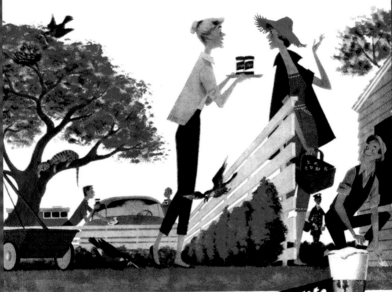

SCHLITZLIGHT

...kiss of the hops

Never bitter. No aftertaste. Salt-free. No heaviness, even with meals. Schlitzlight, sits light. Refresh your leisure and your pause-time without feeling full.

SCHLITZKEPT

...air-free

Like peeled fruit, beer loses flavor when exposed to air. So Schlitz is brewed air-free, air-sealed. Helps keep its fresh, Schlitzdraught taste in bottles and cans.

SCHLITZNESS

...continuous quality

Your tavern keeper will tell you Schlitz is the most dependable beer brewed. That's why it's the world's best seller. You pay so little more. You serve it so proudly.

Schlitz

Be a Schlitzer...Be refreshed

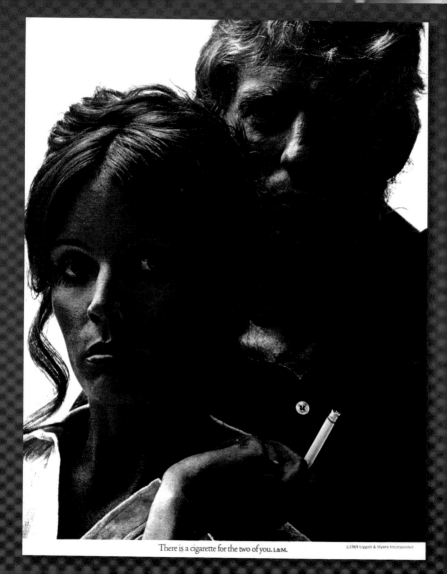

There is a cigarette for the two of you. L&M.

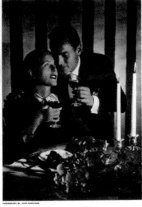

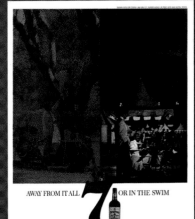

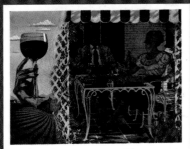

The term *honeymoon* comes from ancient Babylon, where the father of the bride provided his son-in-law with all the mead (a fermented honey-based beverage) he could stand for a month after the big day. This happy time became known as the *honey month*, or, in their lunar-based calendar, the *honeymoon*.

Drink Wonderful

GALLO

PORT

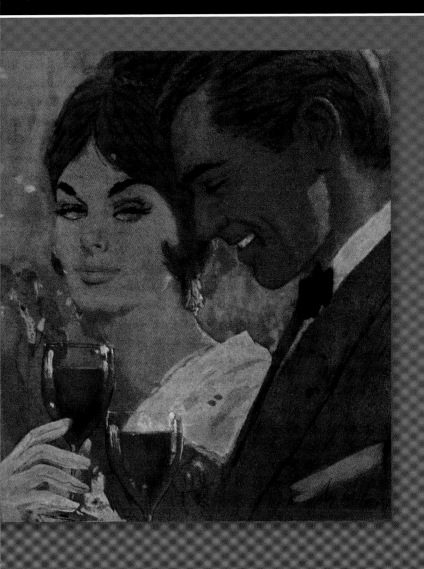

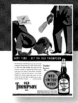

I love to drink martinis.
Two at the very most.
Three I'm under the table.
Four I'm under the host.

—Dorothy Parker

Controversy and oppression can be unpleasant under the wrong circumstances, but they are the bedrock on which humor is built. Funny people the world over depend on strife, and those who are constantly called upon to justify their vices become more and more amusing. They will defend to the last their right to smoke and drink and wear lampshades and carry on, and they tend to be quick with a knowing quip unleashed from a hang-the-consequences point of view. This, from Chaucer, just had to be a riot in the fourteenth century: "I hate him that my vices telleth me." It has that sort of angry, Sam Kinison kind of feeling that audiences love.

When Winston Churchill heard that Arab leader King Ibn Saud's religion ruled out smoking and drinking, he was less than empathetic: "I must point out that my rule of life prescribed as an absolutely sacred rite smoking cigars and also the drinking of alcohol before, after, and if need be during all meals and in the intervals between them." He also once received a visit from FDR wearing not a stitch of clothing ("completely starkers," an aide later recounted) — in short, Winston Churchill knew how to have fun.

The bewitching power of vice, the sinking feeling that no matter what you do you'll be drunk and coughing the rest of your days, leads some to a kind of humor of helplessness. Florence King, author of *Confessions of a Failed Southern Lady*, said, "Now the only thing I miss about sex is the cigarette afterward. It tasted so good that even if I had been frigid I would have pretended otherwise just to be

able to smoke it." Even swashbuckling Errol Flynn was no match for vice: "My problem lies in reconciling my gross habits with my net income."

How convenient, then, that humor and advertising go so well together. Make people laugh, say the admen, and the pleasant association pays off in spades.

In the 1940s this approach tended to get a bit wordy. Ads included whole paragraphs of fine-print jokes, "funny" poetry, and text-filled cartoonery. A Paul Jones whiskey ad featured a bit of dramatic interplay between a fur-toting sports booster and a camel. A generation undistracted by MTV and internet porn was willing to read through the jaunty dialogue and chuckle at the hilarity. A Pabst Blue Ribbon ad featured Banker J. Buxtons of Blue Ribbon Town in a full-page sampling of carefully rhymed verse that banked on the funny-names-and-pictures approach. As a concept, it was far more sophisticated than the company's attempt to play off its "double-hopped" brew by portraying two hopping cartoon firemen.

The 1950s was not a time of untamed humor. Staying inside the lines was emphasized, and the ads followed suit. Funny was the glamorous woman so won over by Parliaments that she ringed the rim of her glamorously diaphanous hat with them. Uproarious was the exasperated breadwinner's discomfort at being made to model his housewife's dress while she altered it. Luckily, Old Gold's "rare and aromatic tobacco" and "virgin-pure flax" paper would soothe him when the odious task was completed. Though the laff quotient was anemic, ads did make a move away from verbose and toward succinctly high concept.

Experimentation crept in during the 1960s, as ads started to get (comparatively) arty. The move toward a hit-and-run concept continued its progress. Tony Randall promoted Heublein whiskey by playing the "bored" (pre-Heublein) and "happy" (drunk) husband. Camel threw a clown into the mix, figuring, apparently, that clown equals funny. What they got instead equaled creepy, i.e. a clown relaxing between shows with a copy of *Variety* and a Camel. (Question: Do clowns read *Variety*?) Ballantine put Ronnie Colville, master blender, on the shores of Loch Lomond with a duck in his lap, but retained a 1940s flavor with several paragraphs of explanation. Legendary sloganeer James Jordan changed everything with Tareyton's grammatically challenged "Us Tareyton Smokers would rather fight than switch!" campaign, which was a hugely successful example of the advertising industry's movement toward unadorned, and therefore repeatable, tent-pole concepts. Things would (Where's the Beef?) never be the same.

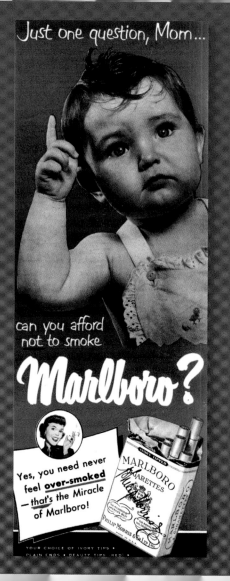

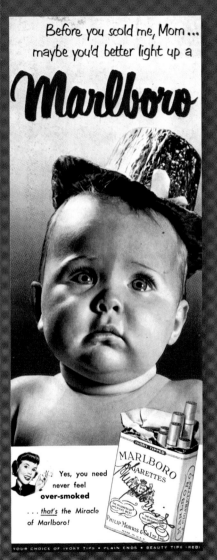

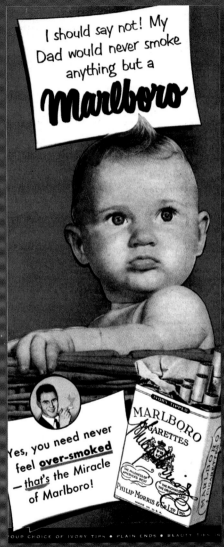

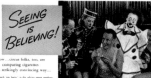

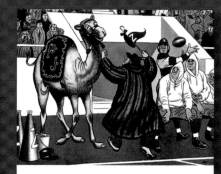
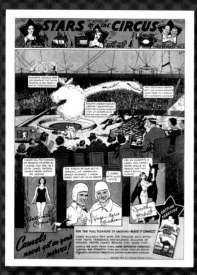
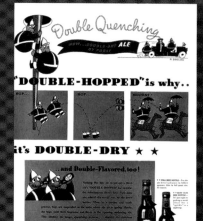

A hangover is really mini-withdrawal from the massive depressant effects of alcohol on the body. Tremors are the manifestations of the body's systems trying to return to normal, as are headache, upset stomach, early morning awakening, rapid heart rate, and heartfelt promises to never touch another drop.

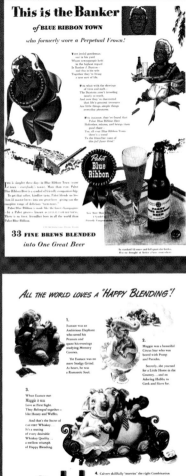
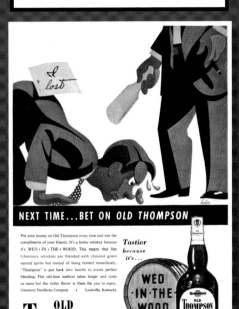
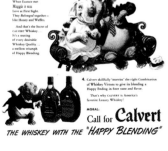

Philip Morris prohibits smoking near manufacturing machines (machines that produce 900,000,000 cigarettes each day) in its plants because particulates in cigarette smoke can damage machinery and electronic equipment.

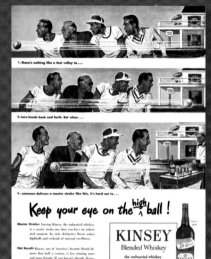

1—There's nothing like a fast volley to...

2—turn heads back and forth. But when...

3—someone delivers a master stroke like this, it's hard not to...

Keep your eye on the high ball!

KINSEY
Blended Whiskey
the unhurried whiskey
for unhurried moments

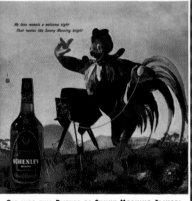

My lens reveals a welcome sight
That tastes like Sunny Morning bright

GET INTO **THIS** PICTURE OF SUNNY MORNING FLAVOR!

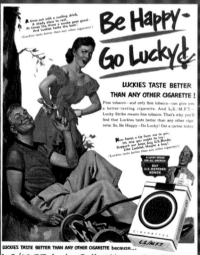

Be Happy—
Go Lucky!

LUCKIES TASTE BETTER THAN ANY OTHER CIGARETTE!

Fine tobacco—and only fine tobacco—can give you a better-tasting cigarette. And L.S./M.F.T.—Lucky Strike means fine tobacco. That's why you'll find that Luckies taste better than any other cigarette. So, Be Happy—Go Lucky! Get a carton today.

LUCKIES TASTE BETTER THAN ANY OTHER CIGARETTE because...
L.S./M.F.T.- Lucky Strike Means Fine Tobacco

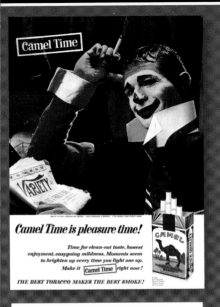

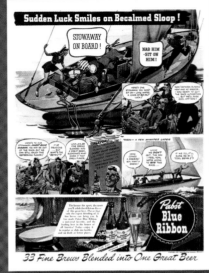

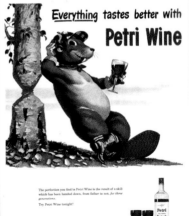

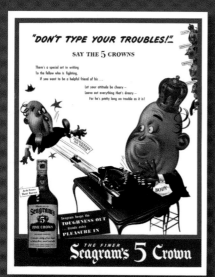

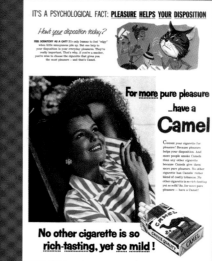

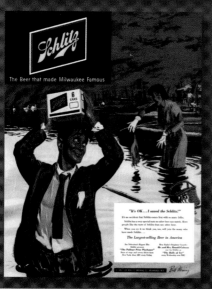

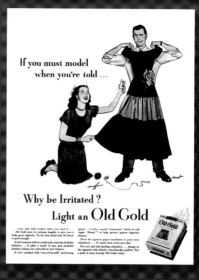

With the economic confusion after World War II, cigarettes became the unofficial currency in many European countries.

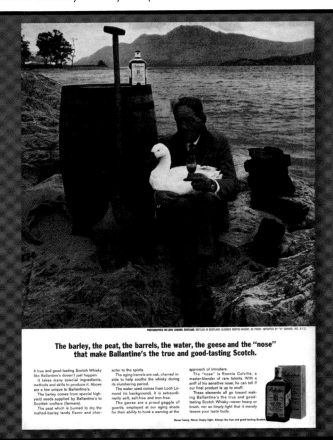

PHOTOGRAPHED ON LOCH LOMOND, SCOTLAND. BOTTLED IN SCOTLAND. BLENDED SCOTCH WHISKY, 86 PROOF. IMPORTED BY "21" BRANDS, INC., N.Y.C.

**The barley, the peat, the barrels, the water, the geese and the "nose"
that make Ballantine's the true and good-tasting Scotch.**

A true and good-tasting Scotch Whisky like Ballantine's doesn't just happen.

It takes many special ingredients, methods and skills to produce it. Above are a few unique to Ballantine's.

The barley comes from special high-yield seeds supplied by Ballantine's to Scottish crofters (farmers).

The peat which is burned to dry the malted-barley lends flavor and char-acter to the spirits.

The aging barrels are oak, charred in-side to help soothe the whisky during its slumbering period.

The water used comes from Loch Lo-mond (in background). It is extraordi-narily soft, salt-free and iron-free.

The geese are a proud gaggle of guards, employed at our aging sheds for their ability to honk a warning at the approach of intruders.

The "nose" is Ronnie Colville, a master-blender of rare talents. With a sniff of his sensitive nose, he can tell if our final product is up to snuff.

These elements all go toward mak-ing Ballantine's the true and good-tasting Scotch Whisky—never heavy or brash, nor so simply-light that it merely teases your taste buds.

Never heavy. Never simply-light. Always the true and good-tasting Scotch.

During World War II, a group of alpine soldiers stuck in mountain snows survived for an entire month on just a cask of sherry.

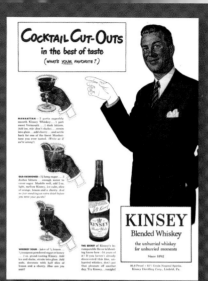

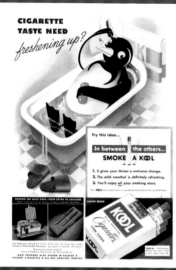

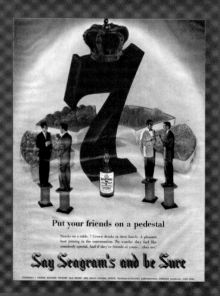

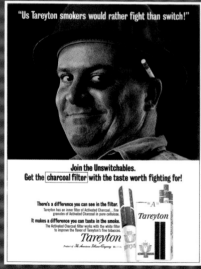

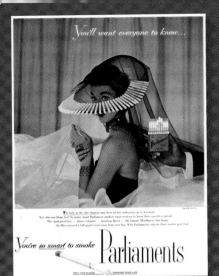

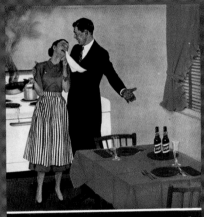

In 1957 President Dwight D. Eisenhower held a press conference to discuss his battle to quit smoking post-heart attack. "I'm a little like the fellow who said I don't know whether I'll start again, but I'll never stop again."

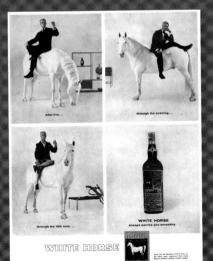

The U.S. Marines' first recruiting station was in a bar.

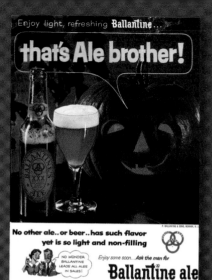

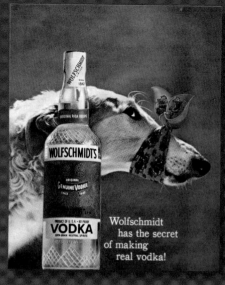

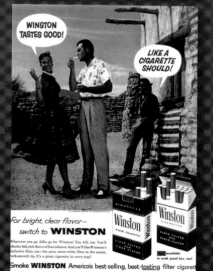

The favorite cocktails of several
former presidents are reported to
include:

Gin and tonic (Gerald Ford)

Martini (Herbert Hoover)

Rum and coke (Richard Nixon)

Scotch or brandy (Franklin Roosevelt)

Bourbon (Harry Truman)

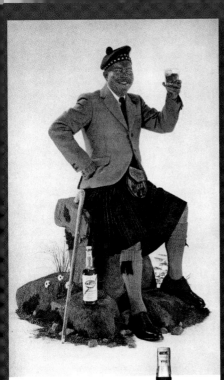

The happiest
scotch-
on-the-
rocks

MELLOW,
LIGHT...
JUST RIGHT
FOR
TONIGHT

MARTIN'S V.V.O.

BRAND

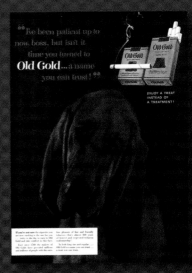

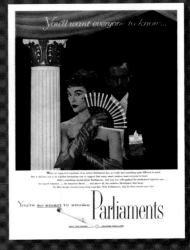

It can be said that we never feel more in control of our destiny, more like we're making our own independent choices, than when we're choosing to take in something toxic. Yes, we've heard the warnings; we know that our vices are not good for us. But so often the consequences are outweighed by the fun we have partaking. Otherwise, Prohibition would have stuck, and you wouldn't see people smoking outside, even in freezing weather, adapting to indoor smoking bans. During the Golden Age of vice advertising, there was a giddy sense that smokes and drinks were magical, guilt-free social emollients that made life better, at no cost to you. Nobody's apologizing in the ads from that period, because they didn't know they had to. Compare those times with now, when ominous studies abound and health scares are commonplace. We no longer have any illusions as to the risks posed by drinking and smoking, and the fact that we continue to indulge says something about the power of vice.

A look to our leaders indicates exactly how abstemious we're willing to be: Huey Long ran a successful political machine out of Louisiana in the 1930s, first as governor, then as a U.S. Senator. He looked like a strong presidential candidate until he was assassinated in 1935. All of this despite Belushian appetites, one of which once led him to a public bathroom, blotto and impatient. Noting that all the urinals were occupied, Huey hit upon a solution: aim between the legs of the fellow in his way. A brawl ensued, and The Kingfish was bloodied. Or think back to Marion Barry, esteemed mayor of our nation's capital in the 1990s, who had this to say in response to one of the many rumors floating around him: "First, it was not a strip bar, it was an erotic club. And second, what can I say? I'm a night owl." Then there was the time he was caught on tape smoking crack with a prostitute. As a scandal, not too shabby. But Barry served

his time and got right back in the race; he was re-elected in 1994. In case you think this is a thing of the past, consider Jerramiah Healy, a New Jersey mayoral candidate who was photographed by a passerby on his front porch, drunk, unconscious, and naked. His defense? He didn't know how he got there, what with the blackout and all. On November 2, 2004, the people spoke, and Healy was elected.

Vices are inextricably woven into our cultural fabric, and they're not going away. So hug your vice of choice to your chest; go out and tipple, or buy a cigarette holder and act like Gloria Swanson. Indulge if you must; just don't do it until it hurts. After all, we need you in fighting shape for that big toga party next weekend.

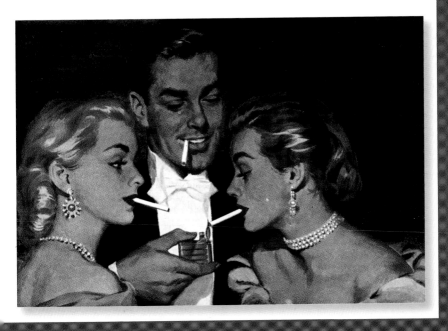

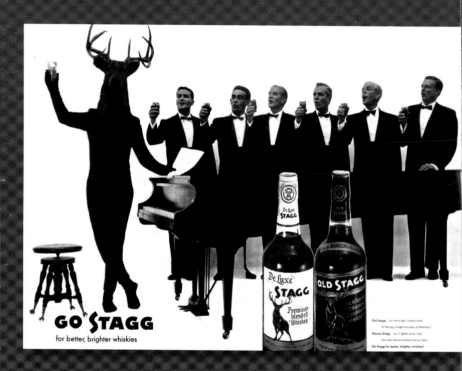

GO STAGG
for better, brighter whiskies